100 Portraits of Christ

100 PORTRAITS

OF CHRIST

HENRY GARIEPY

VICTOR BOOKS®

A DIVISION OF SCRIPTURE PRESS PUBLICATIONS INC.
USA CANADA ENGLAND

Contents

OUR LORD'S ETERNITY

OUR LORD'S EARTHLY LIFE AND MINISTRY

OUR LORD'S ABIDING MINISTRY

OUR LORD'S
SELF-PORTRAITS ("I AM'S")
(except "Alpha and Omega" and "I Am," included as numbers 1 and 14)

INDEX

Preface

This book is a biography of the person and ministry of Christ, as revealed by 100 names and titles ascribed to Him in Scripture. Each name and title is a revealing portrait of our Lord, providing the reader with fresh insights and applications of their meaning for Christian living.

The portraits are in four divisions, the first portraying Our Lord's Eternity. The reader here encounters such magnificent presentations of Christ as *Alpha and Omega, The Mighty God, Radiance of God's Glory*. The second gallery of portraits is of our Lord's Earthly Life and Ministry. Here one finds the warm and human portrayals of Christ as *Jesus, Brother, Nazarene, Carpenter, Jew, Teacher, Physician*. A deeper appreciation will come for the familiar portraits of the third section on Our Lord's Abiding Ministry. There will be a kinship with such delineations as *Friend, Saviour, Lord, Our Hope, Pioneer of our Salvation, The King of kings*. Our Lord's self-portraits culminate the series with such sublime revealings as *Light of the World, The Good Shepherd, Resurrection and the Life, The Way, Bright Morning Star*.

This devotional study of 100 portraits of Christ leads the reader to know our Lord better and to more faithfully follow Him in his daily Christian life.

There are few works that will be as revealing and helpful on the most important subject of all—Jesus Christ.

Introduction

"What's in a name?" To this question of Shakespeare we would have to answer that a name is a very important part of a a person. Parents consider carefully and often struggle over the selection of a name for their child. A name is more than a label of identification.

It was not too long ago that our Anglo-Saxon names were assigned with special meanings. Lineage was indicated by names, for example, Johnson, Ericson, Peterson. Occupations were often indicated in names such as Smith, Miller, Carpenter. Thus a name often gave some knowledge about the person.

Goethe speaks of a name being inseparable from a person:

> A man's name is not like a mantle which merely hangs about him . . . but a perfectly fitting garment, which, like the skin, has grown over him, at which one cannot rake and scrape without injuring the man himself.

In biblical times, a name had significant meaning. Often a name would denote a characteristic or something related to the history of the person or his time.

Sometimes a new name was given to indicate a change of character or an epochal event in one's history. In the covenant God entered into with Abram, He changed his name from

Abram to Abraham (Gen. 17:5), the new name signifying *Father of a multitude* or *exalted father.* Jacob's name meant *supplanter* and aptly described his early life. But in his spiritually traumatic experience at Peniel, his name was changed to *Israel* to signify that as a spiritual prince he had power with God (Gen. 32:28). Moses changed Oshea's name to Joshua which means *salvation* and prophetically spoke of his work in delivering Israel from her enemies (Num. 13:16). Isaiah gave his two sons symbolic names relating to his prophecies to Israel (Isa. 7:3; 8:3).

Jesus beautifully prophesied the sturdy qualities to be developed in the big fisherman He recruited as a disciple when He changed Simon's name to Cephas or Peter, meaning *rock* (John 1:42). Saul had such a transforming experience that his name as well as his nature was changed.

One of God's greatest revelations was memorialized in a name. The name Methuselah meant, in essence, *when he is gone it shall be sent.* His name prophesied the deluge. What a testimony to God's grace and forbearance that the one whose lifespan measured the length of opportunity man had to repent and be spared destruction was the longest life lived.

But of all the names in history, none are so significant, so sacred, so sublime and superlative as the names of Jesus. Paul in his great Christological passage exclaims, God "gave Him the name that is above every name" (Phil. 2:9). Many inspired hymnodists caught the theme and penned words that have found an honored place in our hymnbooks. Gloria and Bill Gaither have lyricized for the world to sing:

> Jesus, Jesus, Jesus; There's just something about that name!
> Master, Saviour, Jesus, Like the fragrance after the rain;
> Jesus, Jesus, Jesus, Let all heaven and earth proclaim:
> Kings and kingdoms will all pass away,
> But there's something about that name!*

Throughout the Old and New Testaments, one finds more than 100 names and titles for Jesus Christ, gleaming like jewels with radiance and luster. One of the objects of this writing is to take these names and attempt to set them in a devotional study so that our lives may be further brightened and our hearts illumined by their shining truths. The 100 names and titles selected are those that, on the authority of the Scripture, by ascription or intimation, belong to Christ.

After embarking on this intriguing Bible study, the question posed itself: "Why are there so many names and titles for Christ?" No other personage of history seems to have more than one main title. We have Alexander the Great, William the Conqueror, Washington the Father of his country. But Jesus Christ has over 100 names and titles. Why this many-name quality of our Lord?

Is it not because, though a name is descriptive, it is also restrictive? A name or a title has a self-imposed limitation and no one could begin to describe or define Jesus Christ. In one sense, He is the Unnameable One. His glory and His greatness defy description and definition.

How astonishing it is that we can know Jesus. We visit the great museums of the world and see the work of specialists, men who devote their lives to special fields of knowledge. One learned professor will give years to the study of mammals, another to the study of birds, another to marine life, another to that of insects. Another will devote his life to the study of history, and yet another to astronomy. The knowledge of the naturalist, the historian, the astronomer, may in due time become outdated. But the knowledge of Jesus Christ is of infinite value and timeless. It is profitable for this world and the world to come.

"All the treasures of wisdom and knowledge" declares the Apostle Paul, "are hid in Christ" (Col. 2:3). This study of the names and titles of Christ is an embarking on life's greatest quest in learning, exploring, and discovering the life and lordship, the might and majesty, the saviourhood and sovereignty of Jesus Christ. The more we know of Him, the more we discover there is to learn. All of God's Word is rustling with the revelation and the radiance of the Son of God, treasures of truth awaiting our discovery.

One of the best ways to know and understand Christ is to perceive the portrait that is put together by the mosaic of names and titles revealed in Scripture. Each name and title reveals some unique aspect of His person and His purpose. These names and titles are an index to the nature of Christ.

"No religion has ever been greater than its idea of God," observed A.W. Tozer. He believed that we tend to resemble our idea of God, stating, "Worship is pure or base as the worshiper entertains high or low thoughts of God." For the Christian, it matters a great deal what we think about Christ, what concept we have of Him and His ministry to and through us.

May this study lead us to know Christ better, and knowing Him to love Him, and loving Him to serve Him and reveal His love and power to a world in crisis.

Our Lord's
ETERNITY

Portrait One
ALPHA AND OMEGA

I am the Alpha and the Omega (Rev. 22:13).

This magnificent title of our Lord comes to us in His final words to man as recorded in the last chapter of the Bible. They are spoken in the context of His promise of the Second Coming. Three times in this final chapter He declares, "I am coming soon!" The title "Alpha and Omega" gives authority and credibility to the stupendous promise of His return.

This title is found three times, each in the Book of Revelation. They are believed to be the words of Jesus in 1:8 and the utterance of God the Father in 21:6. Thus here Christ assumes a title which God used in reference to Himself, rendering this title a witness to the divinity of Christ. Deity alone could make such a claim as this title asserts.

Alpha and Omega are words for the first and last letters of the Greek alphabet. Their meaning is explicit in the amplification Jesus Himself gives in 22:13: "The beginning and the end, the first and the last."

He is *Alpha*, the Beginning, the First. What a staggering claim! First—before the empires of Egypt, Babylon, Greece, Rome. First—before the eons of time spoken of by geologists. First—before the solar system, the Milky Way, the Pleiades.

He is *Omega*, the End, the Last. What a blessed assurance. Although Dante's great work was filled with tragedy, he entitled it, *The Divine Comedy*, because of his belief that in the end God would give happiness to His people. Because Jesus Christ

is the End as well as the Beginning, *Omega* as well as *Alpha*, eternal felicity will be the conclusion for His people.

"Father Time" is looked on as both a tyrant and a friend. Time will write wrinkles in our faces, scribble crow's feet about our eyes, turn our hair white (if it doesn't take it away altogether), rob us of our vision and vigor. But time can also be a corrector of errors, a confirmer of truth, a healer of sorrows, our best tutor. Andrew Marvell describes the remorseless rush of time in unforgettable lines:

> But at.my back I always hear
> Time's winged chariot hurrying near.

But Jesus has no beginning nor ending. He is eternal. Even our calendars pay homage to His superiority over time.

There is another intriguing and inspiring dimension to this title. The alphabet represents absolute wholeness, completeness. It is an inexhaustible resource for all to tap. The same 26 letters used by Shakespeare to write immortal lines have been used by lovers to express their feelings, by judges to pass sentences, by Presidents to issue proclamations, by a parent to guide a child. Jesus Christ as our Alpha and Omega is our resource and inspiration for the whole realm of life and communication.

As our Alpha and Omega, He is also the Lord of our beginnings and endings. He is there at the thresholds of our lives—birth, growing up, when the young person goes off to college, at the marriage altar, at the start of a career, when the first child comes, new undertakings, and all our important beginnings.

He is there in our endings—when we leave home, at the completion of a task, the end of a stay, leaving a place and friends behind, loss of a loved one, retirement, death.

We take comfort and courage from this title with its assurance that our times are in the hands of the eternal, our life becomes complete in Him and He is the Lord of our beginnings and endings.

Eternal Christ, be the Alpha and Omega in my life. Be in all my beginnings, and in my endings.

Portrait Two
THE MIGHTY GOD

And He will be called . . . Mighty God (Isa. 9:6).

Many have tried to escape the force of this declaration. However, Scripture, history, and human experience corroborate its sacred and sublime truth.

In John's prologue to his Gospel, he gives us a breathtaking opening statement that declares three transcendent truths about Jesus Christ.

1. He was eternally existent—"In the beginning was the Word."
2. He had fellowship with God—"and the Word was with God."
3. He was God—"and the Word was God."

In that same prologue we read, "Through Him all things were made; without Him nothing was made that has been made" (John 1:3). The same truth is reaffirmed in the Pauline text of Colossians 1:16. Jesus is declared to have been an Agent of Creation. Before He ever came to earth, His hands tumbled solar systems and galaxies into space. He set the stars on their courses. He kindled the fires of the sun. He scooped out the giant beds of our mighty oceans.

> His holy fingers formed the bough
> Where grew the thorns that crowned His brow.
> The nails that pierced the hands were mined
> In secret places He designed.

He made the forests whence there sprung
The tree on which His holy body hung.
He died upon a cross of wood
Yet made the hill upon which it stood.

The sun which hid from Him its face
By His decree was poised in space.
The sky which darkened o'er His head
By Him above the earth was spread.

The spear that spilt His precious blood
Was tempered in the fires of God.
The grave in which His form was laid
Was hewn in rocks His hands had made.

F.W. PITT

He created not only the macroscopic with its fiery planets and its unimaginable reaches of intergalactic space, but He created the microscopic as well. He polished the eye of every tiny insect, painted the bell of the lily, and crafted the exquisite geometry of the snowflake. He is the One who has made "all things bright and beautiful, all things great and small."

He is the Mighty God in His preincarnate glory and splendor. He was mighty in His birth when time was invaded by eternity and split in two. He was mighty in His ministry and His incomparable miracles. He was mighty in His teachings, putting the imperishable truths of the kingdom into word forms so indestructible that man could never forget them. He was mighty in His death as He rescued us from the hell we deserve and made us heirs to the heaven we forfeited. He was mighty in His resurrection as He arose, the Mighty Conqueror, over man's last enemy. He will be mighty as He comes again in His matchless and transcendent glory.

Mighty God who holds the vast reaches of the universe, thank You for holding my frail life in Your mighty hands.

Portrait Three
THE EVERLASTING FATHER

And He will be called . . . Everlasting Father (Isa. 9:6).

We usually associate the name of Father with the first Person of the Godhead, but here the title belongs to Christ. However the original text does not denote *father* in the usual association we have with that word. It means in this verse *author* or *possessor*. A more exact rendering of this verse would be "the Father of Eternity" as it is rendered by the *Amplified Old Testament*. Thus, this verse speaks of Christ as the Eternal One and as the One who holds eternity in His possession. Vast, unfathomable eternity is His.

One of the most intriguing exercises for the imagination is to consider the eternity of Jesus. It staggers the mind. Jesus always was; He had no beginning. As God, He is the great First Cause of all things. If we could turn back time and look down the dim corridor of the ages, we would find Jesus with the Father at the beginning. He was there when the planets and the universe were created. He antedates the eons of time geologists tell us were involved in the Creation of our planet. He is the unbeginning One.

The Apostle Paul, centuries after Isaiah, writing of the eternal existence of Christ, states: "He is before all things" (Col. 1:17). In that same text he tells us that all things were created by Christ (v. 16). We reckon our time in terms of B.C. and A.D.—before or after Christ. But Paul is here speaking of P.W. time—"pre-world" time. We have a here and a hereafter. But

23

Christ had a before, a here, and a hereafter. Jesus Himself referred to His pre-world splendor in His prayer in the Upper Room when He asked His Heavenly Father: "Glorify Me in Your presence with the glory I had with You before the world began" (John 17:5).

People ask, "Who *were* Buddha and Napoleon?" But always, "Who *is* Jesus Christ?"

Not only is Jesus Lord of the past and the present, but as the possessor of eternity, He holds the future in His hands. Jesus the timeless, holds all time in His hands. We may not know what the future holds, but we know who holds the future.

In one of those texts that stands as a sovereign mountain peak of truth that dominates the landscape of life, we read, "He has also set eternity in the hearts of men" (Ecc. 3:11). All around us God has put intimations of our immortality. There is within us an unrelenting intuition to see beyond temporal horizons and to press beyond the limits of the finite. We are haunted by a sense of destiny. Eternal forces ripple in our blood. Immortal calls echo in our ears. Sublime visions flash on the screens of our imaginations. Eternity beckons as deep calls unto the depths God has put in our soul. With Francis Thompson, from his haunting *The Hound of Heaven*, we hear the sound of a distant trumpet:

> Yet ever and anon a trumpet sounds
> From the hid battlements of Eternity.

Paul affirms: "The gift of God is eternal life in Christ Jesus our Lord" (Rom. 6:23). What a soul-stirring truth—Jesus Christ shares His eternity with us.

Because Jesus Christ is eternal and He has made us joint heirs with Him, we shall share eternity with Him. The short day of our earthly life is only a prelude and a brief preparation for the higher life that is beyond. Our life is larger and longer than we dream. There is much more to life than meets the eye when it is linked with the One Isaiah calls *Everlasting Father*.

Eternal Christ, help me to so pass through things temporal that I shall not forfeit the things that are eternal.

Portrait Four
ANCIENT OF DAYS

Thrones were set in place, and the Ancient of Days took His seat (Dan. 7:9).

Three times the title "Ancient of Days" is used in the seventh chapter of Daniel for Christ (vv. 9, 22) and God (v. 13).

We live under the tyranny of the clock and the calendar. We are but a brief episode in eternity, a child of the hour in which we were born. If favored by health and circumstance, we may play through our seven acts on the stage of life until we come to Shakespeare's "the lean and slippered pantaloon, sans teeth, sans eyes, sans taste, sans everything."

But Christ is the Master of time. Born in a wayside stable, He divided time in two. In the year 541, Dionysius the Little, first ranged the history of mankind around its most important event—the birth of Christ. Every time we write a date, we are acknowledging that all else in human history is to be reckoned in relation to Jesus Christ. Time is subordinate to the sovereignty of the One who is the "Ancient of Days."

We raise our voices in singing the words of Robert Grant:

> O worship the King all glorious above,
> And gratefully sing His wonderful love;
> Our Shield and Defender, the Ancient of Days,
> Pavilioned in splendor and girded with praise.

Eternal Lord, how reassuring for me to say with the psalmist: "My times are in Your hands."

Portrait Five
IMAGE OF THE INVISIBLE GOD

He is the Image of the invisible God (Col. 1:15).

In the title verse above, the Greek word *eikon* (translated "image") had a rich association in the New Testament world. It is one of those words difficult to translate from the Greek, not having an English equivalent. It is also the word employed in 2 Corinthians 4:4 where Christ is spoken of as the "Image of God." Though it does connote likeness, its meaning goes beyond that. It means more than an accidental similarity such as one person to another. It represents more than an artificial imitation. It implies an original or an archetype from which the image is drawn.

All students of this text are deeply indebted to Bishop Lightfoot's incisive commentary on it. He writes, "Beyond the very obvious notion of likeness, the word for image involves the idea of representation and manifestation."

Thus Christ as the Image of God is the representation of God. He possesses all the essential qualities of Deity. Just as on analysis a tiny drop of the ocean has all the same elements of the vast ocean, so Christ in human form represented the essential characteristics of Divinity. In Him we see the righteousness of God, the judgment of God, the purity of God, the character of God, the mighty love of God, the power of God.

Christ was the visible manifestation of the Invisible God. Jesus, in His revealing dialogue with Philip in the Upper Room

said, "Anyone who has seen Me has seen the Father" (John 14:9). He was the Infinite Lord who had become the Intimate Life. He was the embodiment of Deity. He was God in human flesh and form. He was God speaking the language of the man in the street. He was God in understandable terms.

When we think of God we think of Christ. He is our mental image and concept of what God is like. The imagination cannot frame a more noble picture, the intellect cannot conceive a higher concept, nor can the soul devise a more exalted image of God, than that He should be like Christ. He is God's self-disclosure.

There are two other titles closely related to this one. In Hebrews 1:3, Christ is called the "radiance of God's glory." We cannot look directly at the brilliance of the noonday sun. But its rays and its warmth reveal to us what the sun is like. Christ was the ray that penetrated the earth's dark atmosphere and enabled men to see and know something of the glory and the effulgence of the Eternal Light.

In Hebrews 1:3 (KJV), Christ is also called the "express image of His person." We have in the original text the interesting word *charakter* for "express image." It was the word that described the impression of a seal left on wax or clay. Thus Jesus as the *charakter* of God is a faithful and detailed reproduction of the nature of God. In His life and ministry there was faithfully traced the character of deity.

Catherine Baird's words beautifully express in devotional words God as Love revealed in Christ:

> O Love, revealed on earth in Christ,
> In blindness once I sacrificed
> Thy gifts for dross; I could not see
> But Jesus brings me sight of Thee.
>
> O Love, invisible before,
> I see Thee now, desire Thee more;
> When Jesus speaks, Thy word is clear;
> I search His face and find Thee near.

Eternal Christ, I thank You for making God real and known to me in history and in my heart.

28

Portrait Six
FIRSTBORN OVER ALL CREATION

He is . . . the Firstborn over all Creation (Col. 1:15).

This great title was born on the battlefield of New Testament theology. A deadly enemy to the Christian faith and early church rose up, known as Gnosticism. It has kinship today with syncretism which is on the rise in some parts of the world. The Gnostics at Colossae tended to incorporate ideas from other philosophies and religions on a level with Christian truth. It may have seemed harmless, but Paul knew it struck at the very heart of the Christian faith. It was a challenge to the supremacy of Christ.

Paul's letter to the Colossians was written to refute this heresy. Paul cogently argues the supremacy of Christ. It is the central and pivotal point of his theology. Christ is not merely one among many emanations of Deity, but Sovereign over all. That is what this transcendent title means—He is the Firstborn over all Creation. It is a stupendous statement.

Paul goes on to describe in unequivocal terms, and in one of the most sublime Christological passages found in the Bible, the supremacy of Christ:

> He is. . . the Firstborn over all Creation. For by Him all things were created: things in heaven and on earth, visible and invisible, whether thrones or powers or rulers or authorities; all things were created by Him and for Him. He is before all things, and in Him all things hold

together. And He is the head of the body, the church; He is the beginning and the Firstborn from among the dead, so that in everything He might have the supremacy. For God was pleased to have all His fullness dwell in Him, and through Him to reconcile to Himself all things, whether things on earth or things in heaven, by making peace through His blood, shed on the cross (1:15-20).

The word *firstborn* is translated from the Greek *prototokos.* The word portrays two eternal facets of Christ. It declares that He is the Head of Creation. "Firstborn" does not refer to age but to supremacy over all Creation.

It suggests His preexistence, His eternity. He is the Unbeginning as well as the Unending One. He always was. Before the eons of time recorded in the geological strata of the earth, before the stars were set on their courses, Christ was. He is the Timeless One who holds all time in His hands. Our finite minds cannot grasp the infinite aspect of Christ. We just cannot conceive how Christ and God always were, having had no beginning. But then if the finite could comprehend the Infinite, the Infinite would be finite.

Edwin M. Stanton, Secretary of War, had been kneeling by the bedside of a gaunt, haggard figure. He arose in that historic moment as Lincoln expired and said, "Now he belongs to the ages." Those words in a far superior way are true of Jesus Christ. He alone belongs to all the ages. Christ belongs to no particular age, no era or epoch. He is the Eternal One. His short sojourn on earth was but a moment, a minute fraction of time in His eternal existence.

This word *prototokos* also speaks of the precedence of Christ in all creation. The Hebrew equivalent of this term in the Old Testament is consistent with the precedence of the firstborn being destined as the heir and ruler (see Ps. 89:27).

Christ must have precedence over all other things. St. Augustine wrote, "Christ is not valued at all unless He be valued above all." Christ is not Lord at all unless He is Lord of all. To some people Jesus is nothing. To others, He is something. Then there are those to whom Jesus is everything.

Lord Jesus, reign supreme over all else in my life.

Portrait Seven
HEIR OF ALL THINGS

*But in these last days He has spoken to us by His Son, whom
He appointed Heir of all things, and through whom He made the
universe (Heb. 1:2).*

The grandeur and the glory of this title are unfathomable to
human finite minds. The inheritance of Christ has no qualifica-
tion or restriction whatsoever. He is the Heir of all things.

This verse has a companion text: "The kingdom of the world
has become the kingdom of our Lord and of His Christ, and He
will reign forever and ever" (Rev. 11:15). These words from the
great seer's rapturous vision speak of the eternal kingdom and
glory of our Lord. It was the assurance of this truth that
sustained the martyrs in their hours of testing and tragedy. It
is the truth that can give new life and incentive to our evange-
listic thrust of today. There will be a great Coronation Day for
the One who is the Lord of lords and the King of kings. This
world will become His kingdom.

By what right does Christ become Heir of all things? Our text
declares first of all that it is by the *right of relationship*. He is the
Son of God. The word *heir* as a legal term refers to one who
comes to an inheritance by natural right rather than by a will.
Under our intestacy laws, when a person of wealth dies with-
out a formal will, the inheritance is often determined by a
degree of consanguinity or blood relationship. The nearest of
kin is given precedence. Christ's unique relationship to God as
His Son gives Him natural right to all of God's universe.

Secondly, Christ becomes Heir by *divine appointment*. God
has appointed Christ as Heir. God is the Cosmic Legator. Thus

31

Christ's right to the inheritance is incontestable.

Christ also has His right of the inheritance of the cosmos derived from *His own supremacy*. Our verse states that Christ was an agent of the Creation. This truth is revealed in other passages of Scripture as well. His is the right of the Creator. To a creator belongs that which he brings into existence.

There is another glorious truth of Scripture related to this great title: "The Spirit Himself testifies with our spirit that we are God's children. Now if we are children, then we are heirs—heirs of God and coheirs with Christ, if indeed we share in His sufferings in order that we may also share in His glory" (Rom. 8:16-17). Hallelujah! He shares His inheritance with us! Mansions of glory, life that shall endless be, worlds unknown, knowledge now unimaginable, eternal fellowship with God— all this and more than we can begin to conceive. "No eye has seen, no ear has heard, no mind has conceived what God has prepared for those who love Him" (1 Cor. 2:9).

A story is told of Theodore Roosevelt boarding ship at an African port as he was to return from a hunting safari. Great crowds gathered to celebrate his visit. The red carpet was rolled out for him. He was given the best suite on board the ship. He was the center of attention during the sail home. At the same time, there was another man on board ship. He was an old missionary who had given his life for God in Africa. His wife had died, his children gone, he was now alone. No one noticed him. At the ship's arrival in San Francisco, the President was again feted. The whistles blew, the bells rang, the crowds cheered as Roosevelt disembarked in pomp and glory. But there was no one there to meet the missionary. He went to a small hotel room and that night as he knelt beside his bed he prayed, "I'm not complaining, Lord. But I just don't understand. I gave my life for You in Africa and it seems that no one cares. I just don't understand." And then it seemed in that moment the Lord reached down His hand from heaven and placing it on the old man's shoulder, said, "Missionary, you're not home yet."

Eternal Christ, my imagination and mind reel at the thought of Your infinite love. Enable me to be a more worthy heir to Your promises.

32

Portrait Eight
RADIANCE OF GOD'S GLORY

The Son is the radiance of God's glory (Heb. 1:3).

The glory of God is beyond comprehension. Glory is the essential nature of God; it is that which makes God God. Glory includes beauty, majesty, splendor, greatness, power, eternity. This word is without peer in reference to God.

Moses had prayed, "Show me Thy glory." But mortal capacity has its limits and man could not look upon the ineffable glory and flaming splendor of the infinite God. The great lawgiver, huddled in the cleft of a rock, had to be content with but a glimpse of the burning skirts of the One who is eternally clothed in majesty and holiness and before whom suns are but as candles and stars as jewels in His diadem.

But the sacred record tells us that God in Christ was made flesh and "we have seen His glory" (John 1:14). The perfect life of Christ revealed the glory of God as graphically as possible to human understanding. Jesus was the embodiment of the qualities of the Godhead. In Christ, we see God's glory.

James Irwin, commander of Apollo 15, said he had never felt closer to God than on his space flight. He shares that while walking on the moon, the thought came to him that this was the greatest event in the history of the world—man walking on the moon! But then he adds, the Lord spoke to him and said, "I did something greater than that. I walked on the earth."

Lord Jesus, thank You for Your revelation of the glory of God.

Portrait Nine
EXACT REPRESENTA-TION OF HIS BEING

The Son is the . . . exact representation of His being
(Heb. 1:3).

The writer of Hebrews begins his profound book with a delineation of the preeminence of Christ. He sets forth Christ's credentials as God the Creator—"through whom He made the universe." He made the Sea of Galilee as well as hushed it. He could restore the blind man's sight, for He first made the optic nerve and retina. He could give hearing to the deaf man, for He first set the drum in the ear. He could cure the withered arm, for He made the bone and strung the muscle.

The Christ who walked the dusty roads of Galilee was the God who had roamed through the paths of galaxies. The Christ who lit the lakeside fire on which to cook breakfast for His tired, hungry disciples, had lit a billion stars and hung them across the midnight sky. He who asked the outcast for a drink had filled with water every river, lake, and ocean. Christ became God's self-disclosure. In Jesus, God entered humanity, eternity invaded time.

A statue of Lord Nelson on top of a pillar in the middle of Trafalgar Square in London was so high that you could not see the features of Lord Nelson. An exact replica of the statue was put at eye level so that everyone could see its finer features. Our Lord came to earth and in Him we see what God is like.

Lord, turn my mirrors into windows so I shall see more of
Your revelation of God and His will for me.

Portrait Ten
WORD

His name is the Word of God (Rev. 19:13).

History has proven that the pen is often more powerful than the sword. Words have swayed empires, preserved the freedom of embattled peoples, drastically altered the course of history. Words are also an index to the person who utters them. They reveal how vivid is the person's encounter with life, how vibrant is the personality behind them.

The Greeks had three words for *word*. One meant the sound of a voice, another was a sound revealing a mental state, and the third is the one of our text. It is one of the great words of the Greek New Testament—*logos*. *Logos* combines the thought of expression and wisdom. It means a word which embodies a concept or idea. This rich word is not easily translatable into English. Moffatt leaves it untranslated and renders John 1:1:

> The Logos existed in the very beginning,
> the Logos was with God,
> the Logos was divine.

As the Word, Christ was God become *vocal*. "In the past God spoke to our forefathers through the prophets at many times and in various ways, but in these last days He has spoken to us by His Son" (Heb. 1:1-2). No longer would human prophets give a gradual unfolding of the divine message. God would speak His great and glorious message through His Son. Christ became the ultimate medium of communication from God to

37

man. Through Christ, God speaks to man in a new and living language—the language of life in Christ. Jesus is God's supreme articulation to man.

Our text in Revelation speaks of the Word as having His robe dipped in blood. We are reminded that He spoke God's message most eloquently in His sacrifice and death. The cross was the bulletin board on which God proclaimed to the world His amnesty for rebellious sinners.

As the Word, Christ was God become *visible*. A word reveals. It is the revelation of the thought or concept in the mind of another. Although centuries separate us from Milton and Tennyson and Shakespeare, their words reveal their thoughts and their philosophies. As the Word of God, Christ portrays the mind and heart of God. He unveils the mysterious, mighty, magnificent, and majestic God. He makes the transcendent God of the universe immanent upon earth to man.

In Rome there is the elegant fresco known as the *Aurora* by Guido. It covers a lofty ceiling. As one attempts to observe it from below, the neck becomes stiff, the head dizzy, and the figures indistinct. But the owner of the palace has placed a large mirror near the floor. The tourist may now sit before the mirror and, looking into it, enjoy the fresco that is above. So Christ mirrors for us the otherwise inaccessible and invisible cosmic presence above us. He reveals and discloses God.

In his Gospel, John declares five stupendous truths about the Word: (1) His eternity—"In the beginning"; (2) His fellowship in the Godhead—"with God"; (3) His deity—"was God"; (4) His work in Creation—"All things were made by Him"; (5) His marvelous Incarnation—"was made flesh."

A few years before the death of Christ, Philo, an Alexandrian Jew, fused the Greek and Jewish thought on the word *logos* and wrote extensively on it, clothing it with a metaphysical conception. This word came to have more extensive and significant currency, communicating effectively to both Jewish and Greek thought. But Christ was bigger even than this great word and filled it with new meaning.

Living Word, as I study the portraits of Your life and ministry, reveal more of Your radiance and reality to my mind and heart.

Portrait Eleven
THE BELOVED

He has made us accepted in the Beloved (Eph. 1:6, NKJV).

This term of endearment is used of God's love for His Son. At Christ's baptism there was heard the voice of God saying, "This is My beloved Son, in whom I am well pleased" (Matt. 3:17, NKJV). On the Mount of Transfiguration, again we hear the voice from heaven, "This is My beloved Son" (Matt. 17:5, NKJV). Each time the veil of heaven is drawn back a little, as it were, this term is used. There is no term that expresses so perfectly the relationship between God the Father and the Son as "the Beloved."

Christ is the Beloved of God. He has been loved by God through all eternity. God's love transcends all human love. Human love compared to the love of God is as a flickering candle to the blazing sun. This term "beloved," referring to God's love for Christ, is supremely invested with the highest and holiest love of the universe.

Our text declares a beautiful and blessed truth. Because God loves Christ with such an infinite love, on the merit of what Christ did for us, we are accepted by God. Acceptance is an important part of life. Its opposite, rejection, can make life lonely, despairing. People will go to great lengths to gain acceptance. Our text tells us we are "accepted in the Beloved" (Eph. 1:6, NKJV). We are accepted by God, not on any merit of our own, but because of the sacrifice of Christ on our behalf.

It is instructive to note that Paul varies his terms for Christ in

this passage. He has been using the terms "Jesus Christ," "the Lord Jesus Christ," and "Christ." But suddenly he changes to "the Beloved." Why does he make such a major change? It is because he has just stated the tremendous blessings God has given us—chosen to holiness, adopted as sons, loved by God, endowed with every spiritual blessing. And he wants to emphasize that all these awesome things God has done for us, are ours by His love of His Son and what Christ has done for us. Our acceptance by God and the extravagant bounty of God toward us is ours "in the Beloved." This title is a key to the mysteries of God's grace toward us. It is the reason for all the good and all the grace, and ultimately all the glory, that God bestows on us.

Lord Jesus, beloved of God, thank You for the acceptance I have on the merit of Your sacrifice.

Portrait Twelve
ONLY BEGOTTEN SON

For God so loved the world that He gave His only begotten Son (John 3:16, NKJV).

This title comes to us from one of the most beloved texts of the Bible. John 3:16 has been called "the Gospel in a nutshell." It is one of the towering peaks of eternal truth in the Word of God. It proclaims the infinite love of God in immortal words.

This favorite text speaks to us of the divine Person, God the Father—"For God." Its truth deals with the Infinite, the Ultimate Reality, our Creator and Heavenly Father.

It speaks to us of the divine passion—"so loved." It would have been incredible enough for God to love us. But this verse speaks to us of the intensity and the passion of His love for us.

It speaks to us of the divine provision—"He gave." He gives us life, sustenance, bounty, beauty, and blessing to the point of extravagance.

This text and title speak to us of the incalculable divine sacrifice—"His only begotten Son." The modern NIV expresses it "His one and only Son." The words denote the unique, special, precious relationship between the Father and the Son.

We often contemplate the sacrifice of the Son, but this verse would remind us also of the sacrifice of God the Father in the giving up of His Son. On a human level, we hurt deeply when a loved one suffers. The quakes that come into the lives of those we love register high on the Richter scale of our own hearts.

God made the supreme sacrifice in the giving of His Son for

the world. For 33 years, the Godhead was impoverished as our Lord left His Father's home and took on Himself our finiteness and infirmities. We cannot begin to imagine the suffering of God the Father at the violence and injustice to His Son on Calvary. It was "His one and only Son," His Son who was love and purity and justice, whom He saw endure the shame, the mockery, the cruelty, the violence of men. Some have suggested that the darkness which veiled Calvary at the Crucifixion was because God could not bear to look on that scene of the unspeakable suffering of His Son.

And for whom was this sublime sacrifice on the part of God the Father? Our text speaks to us of the person—"whoever believes." Just think, if you are a Christian believer, this is all for you! God loves you, He made the supreme sacrifice for you, and on top of all that, He will give you eternal life!

The hymn of Frederick Lehman, "The Love of God" gives eloquent expression to the truth of this text:

> The love of God is greater far
> Than tongue or pen can ever tell,
> It goes beyond the highest star
> And reaches to the lowest hell;
> The guilty pair, bowed down with care,
> God gave His Son to win:
> His erring child He reconciled
> And pardoned from his sin.
>
> Could we with ink the ocean fill
> And were the skies of parchment made,
> Were ev'ry stalk on earth a quill
> And ev'ry man a scribe by trade,
> To write the love of God above
> Would drain the ocean dry,
> Nor could the scroll contain the whole
> Tho stretched from sky to sky.*

Heavenly Father, Your love surpasses my human understanding, but it captures my heart and claims my life in response.

* Copyright 1917. Renewal 1945 by Nazarene Publishing House. Used by permission.

Portrait Thirteen
GOD

Thomas said to Him, "My Lord and my God!" (John 20:28)

In his devotional classic, Charles Wesley leads us to exclaim in sacred song:

> Amazing love! How can it be
> That Thou, my God, shouldst die for me?

The divinity of Jesus Christ is the cornerstone of Christian theology. This belief is attested by Scripture.

In Philippians 2:6, Paul writes of Christ: "Who, being in very nature God." The word for "nature" in the original Greek text is *morphe*. It is a Greek philosophical term meaning more than shape. It permanently identifies Christ with the nature and character of God. The word denotes that the essential nature of divinity comes from within and is permanently a part of Him.

In contrast, Paul states in Philippians 2:8 that Christ was "found in appearance as a man." The Greek word for appearance is *schema* and denotes that which is assumed from the outside and does not come from within the essential nature. Our Lord's divinity came from His inmost and essential nature, whereas His manhood was assumed from the outside.

John, who had the most intimate contact with Christ, declared that in Christ the "Word was God" (John 1:1). Thomas, who was a follower with a practical bent of mind, on seeing the risen Christ testified, "My Lord and my God!" Paul makes

a superlative statement in Colossians 2:9, "For in Christ all the fullness of the Deity lives in bodily form." In his epistle to Titus, Paul writes: "We wait for the blessed hope — the glorious appearing of our great God and Saviour, Jesus Christ" (2:13).

History also attests to the divinity of Jesus Christ. Emerson said that the name of Christ is not written but plowed into history. Jesus lived and preached in a land about the size of New Hampshire. The crowds who heard Him were much smaller than those who attend a political convention today. But history could not obscure Him. Palestine could not confine Him even though He was put to death as a criminal on a cross.

Our visit to the Colosseum in Rome was a moving experience. We went there several evenings late at night and just mused in that place of sacred history. We tried to envision the scene of the ferocious beasts mauling the Christians amidst the derision of the bloodthirsty crowd. In that very place is erected a cross that enshrines and endears the memory of those who were martyrs for their faith. The Colosseum today and what it represents is but a shadow of what it was once. But on the dust of Rome's fallen glory and on the ashes of her vanished splendor, Christ has built His imperishable church. He towers over the wrecks of time and transcends all eras and splendors of history.

The divinity of Jesus Christ is further corroborated by personal experience. A man newly converted was chided at work: "Now don't tell me you believe that story about Jesus turning water into wine?" The man replied, "I don't know about that, but I can tell you than in my house Jesus has turned beer into furniture!" Countless lives testify of a total transformation, an inward power and peace that results from the divine work of the risen and reigning Christ.

Divine Christ, save me from a limited concept of You. Help me to think and believe big enough and to avoid the pitfall of a myopic faith.

Portrait Fourteen
I AM

"I tell you the truth," Jesus answered . . . "I Am!"
(John 8:58)

Jesus gives us His supreme self-disclosure as He designates Himself by this title, "I Am." It is a title with a sacred history.

When God called Moses to lead the Israelites out of Egypt, Moses asked what he should say when he told the people God had sent him and they asked, "What is His name?" In one of the great moments of revelation in the Old Testament, God replies: "I Am who I am" and instructs Moses to tell them that "I AM has sent me to you" (Ex. 3:13-14).

It is a title that signifies the eternity of God. The Hebrew word for *I am* is in an "imperfect" tense, meaning I was, I am, and I shall always be. It also signifies that God is complete in Himself. He is the source of all being and all other attributes are contained in this title that represents the eternal and mighty nature of God.

There is a revealing incident where Jesus met enraged hostility by the Jews. They charged Him as being demon-possessed and in response to Christ's statement, challenged Him: "Are You greater than our father Abraham? . . . Who do You think You are?" (John 8:53) To these literalists and legalists, Jesus responded: "I tell you the truth, before Abraham was born, I Am" (8:58). There is here a dramatic contrast between the verbs *was* and *am*. Jesus in effect was saying, "Before Abraham came into history, I have been in eternal existence."

It was because of such an absolute claim to divinity that the

Jews picked up stones and unsuccessfully sought to stone Him to death. As R.H. Strachan has fittingly commented: "It is as though the angry waves reared themselves to put out the stars."

In His final hours, at the trial before the Sanhedrin, Jesus was again asked His identity, with the question, "Are You the Christ, the Son of the Blessed One?" Jesus replied, identifying Himself with this title, "I Am." He went on to say, "And you will see the Son of man sitting at the right hand of the Mighty One and coming on the clouds of heaven." Again this title by Christ incites a violent reaction: "The high priest tore his clothes. . . . They all condemned Him as worthy of death" (Mark 14:61-64).

The intense and violent reaction each time Jesus claimed this title indicates its supreme importance. It was a clear proclamation of the divine status of our Lord. It is a supreme disclosure of Jesus Christ as God.

Rudolf Bultmann in his scholarly interpretations of the "I am" sayings of Christ, writes that *ego eime*—"I am"—is a "revelatory formula" that reveals the true nature and essence of Christ. The startling claim of Christ in reply to His hearers on these two occasions was one that was absolute and exclusive, an unequivocal statement of His divinity.

We have seen the reaction of His enemies when Jesus made the claim of divinity inherent in this title. What is our reaction? Do we really accept and know Him as God? Have we allowed Him to reign as Sovereign over our lives? With Thomas, have we said to Him from the depths of our being, "My Lord and my God"?

Lord Jesus, I acknowledge Your divinity with the gift of my total being.

Our Lord's

EARTHLY LIFE AND MINISTRY

Portrait Fifteen
DAYSPRING

The Dayspring from on high has visited us (Luke 1:78, NKJV).

My favorite time of day is the dawn. One's soul is filled with reverence to observe the night giving way to the faint traces of light, then those first intimations of the sunrise as the eastern horizon blushes in rosy-tinted hues at such beauty it is presenting. Then there is that glorious moment when the first fires of the sun appear and this colossal fireball rises in unspeakable splendor, infusing the earth with its warmth and beauty and life-giving rays. It's just like Him—to launch a new day in such extravagant glory!

One of the beautiful titles of our Lord is "Dayspring," which literally means "sunrise." Zechariah in his hymn of praise and prophecy, echoes and announces the fulfillment of Malachi's prophecy (4:2) by the birth of Christ—"The Dayspring from on high has visited us" (Luke 1:78, NKJV).

It was very dark when Jesus, our Dayspring, came from on high. But He came as the glorious sunrise, "to give light to those who sit in darkness and the shadow of death, to guide our feet into the way of peace" (v. 79, NKJV).

Christians of all denominations, join in accord in singing Charles Wesley's hymn:

> Christ, whose glory fills the skies,
> Christ, the true, the only Light,
> Sun of Righteousness arise,

49

Triumph o'er the shades of night;
Dayspring from on high, be near;
Daystar, in my heart appear.

With the hymn writer I would pray, "Fill me, Radiance Divine and more and more Thyself display, shining to the perfect day."

Portrait Sixteen
THE INDESCRIBABLE GIFT

Thanks be to God for His indescribable Gift (2 Cor. 9:15).

The Apostle Paul was writing to the church at Corinth on the subject of giving. He stressed liberality and emphasized that the Christian enriches himself by his giving and so should give, not sparingly, but bountifully. He climaxed his discourse with an exclamation of how extravagantly God has given to us, describing Christ as "His indescribable Gift."

What an appropriate title for Christ. He is God's gift to the world—"For God so loved the world that He gave His one and only Son" (John 3:16). And how true that it is an indescribable gift. No words can define or describe God's gift of His Son. It is a gift that defies description, that transcends superlatives, and exceeds our imaginative powers.

Charles Wesley exclaimed: "O for a thousand tongues to sing/My great Redeemer's praise/The glories of my God and King/The triumphs of His grace." But even then we would not find words to adequately describe the meaning and majesty of the gift of Christ to mankind. This gift of infinite love is beyond the finite grasp of our minds.

The late General Albert Orsborn, leader of the international Salvation Army and considered perhaps the most eloquent of preachers in the movement's history, had to acknowledge: "I earnestly endeavored to center my main reading in books about Jesus Christ. He has ever been the supreme and passionate love of my soul. I have long known that labor, and pray

51

and preach as I may, giving all I am and have to the message, I shall never be able to fulfill my calling. I shall die with my message only partially and poorly spoken."

A young child was having difficulty going to sleep and was heard crying in her bed. After bringing her all the things thought to satisfy, including her favorite stuffed animals, and these attempts failing, her father asked, "What is it that will make you stop crying?" The child answered, "If you will stay with me."

The greatest gift we can give another is the gift of ourselves. As the poet has expressed it, "The gift without the giver is bare." In the gift of Christ, God gave Himself to the world. It is the highest, costliest, most precious gift He could give to us. It is "His indescribable Gift."

Heavenly Father, thank You for giving to me Your very best Gift. In return, I give myself to You.

Portrait Seventeen
ANOINTED ONE (MESSIAH)

Know and understand this: From the issuing of the decree to restore and rebuild Jerusalem until the Anointed One, the Ruler, comes, there will be seven "sevens," and sixty-two "sevens" (Dan. 9:25).

Bible characters are portrayed with brutal candor, "warts and all." However, Daniel is one of the very few in the Bible whose life is presented without any faults. For over 70 years, he served God with steadfast devotion in a foreign land and as a member of a pagan court. His character was irreproachable throughout his long and fruitful life. The secret of his high moral excellence was his prayer life.

In this ninth chapter, there is recorded his eloquent and lofty prayer of intercession. Now over 80 years of age, he was an elder statesman, a vice-president in the palace of one of the world's great empires. His mind and heart were not on the luxuries of the palace but on the plight of his people. He thought of their exile and the destitution of their city and temple. He was moved to this remarkable prayer of earnest intercession for his people and their calamity.

God's answer through the Angel Gabriel far exceeded Daniel's petition. He prayed for the Holy City and its temple and people, but God would send One whose blessings and glory would extend far beyond the bounds of Jerusalem. How often His answers and provisions exceed our askings. In answer to his prayer, God vouchsafed to Daniel a revelation of the coming Messiah. Thus this sacred title is born. It would be the name that would express men's longing and expectation through those silent years of the intertestament period.

Messiah means *the Anointed One or Christ*.

In Old Testament times, there were three offices that involved an anointing with holy oil. Prophets, priests, and kings were thus installed in their offices. Jesus, as the Anointed of God, is all three to His followers. He is our Prophet, Priest, and King.

This revelation of the Messiah pertained not only to His *coming* but also to His *chronology*. Not only was there revealed the person of the Messiah but also the period of the Messiah. It is generally accepted that each week represents 7 years so that the "70 weeks" would be 490 years. This period of 70 weeks reckoned "from the issuing of the decree to restore and rebuild Jerusalem."

In 457 B.C. King Artaxerxes commissioned Ezra to rebuild Jerusalem. The 60 prophetic weeks of verse 25 equals 483 years, which from the date of 457 B.C. brings us to A.D. 26, about the time Jesus is believed to have been baptized. This is representative of His being set apart for the sacrifice for sin.

In this extraordinary revelation to Daniel, not only did God reveal the coming and the chronology of the Messiah but also the *course of events* associated with His coming. These are delineated in verses 24-27 and include:

(1) "To finish transgression, to put an end to sin"; (2) "To atone for wickedness"; (3) "To bring in everlasting righteousness"; (4) "To seal up vision and prophecy." All messianic prophecies would have had their fulfillment in Christ; (5) "To anoint the most holy," or literally "holy of holies." Christ as the new "Holy of holies" would replace the former tabernacle and temple mentioned in the prayer of Daniel; (6) The Messiah would be "cut off"—a reference to His violent death; (7) Jerusalem would be destroyed by a great overflowing of war—a reference to its destruction in A.D. 70; (8) "He will confirm a covenant with many"; (9) "He will put an end to sacrifice and offering." All sacrifices were but types and foreshadowings of His great offering. His death would end the period of legal sacrifices.

Christ, satisfy the deepest longings and expectations of my heart and fulfill Your holy purpose in my life.

Portrait Eighteen
SON OF DAVID

A record of the genealogy of Jesus Christ the Son of David (Matt. 1:1).

This title may not seem too significant to us today. However, the first question put forward in Christ's day about an alleged Messiah would be, "Is he of the house of David?" Any claimant to the title of Messiah would have to pass this genealogical muster. Every devout Jew knew that God had promised, through His prophets, that the Messiah would come from the lineage of David. This genealogical table was necessary to certify Christ's messiahship.

Our text reveals that the tapestry of history is woven with threads from the looms of God. Matthew, with his gift for detail, has arranged His genealogical table into three divisions of 14 generations each. The first period takes us from Abraham to David, from the patriarchs and judges to the period of the monarchy. The second period is from David to the Exile and represents both the flowering and the fading of the kingdom. The final period is that of the Exile and the postexilic period, a time when Israel could have passed into oblivion except for divine providence. It is remarkable that all through these periods, some extremely critical, God preserved the seed of Abraham and David from which would come Christ. History is His story.

It is intriguing to study the names of the genealogy. There are four women, some of them with scandalous and unsavory backgrounds. Ruth represents blood other than that of Jewish

exclusiveness. Some of the names are nondescript and represent anything but luminaries on the horizon of history. The last 10 names are unrecorded in the Old Testament, but how wonderfully God used the weak things, the seemingly insignificant, to bring about His purpose. Each one of the names listed was a vital link in God's chain of history.

This title also links Jesus with humanity. He was born of earthly parentage. Though He was God, He became a man. He was the Ancient of Days, yet He was born at a point in time. He created worlds and companied with celestial beings, yet He came to live in a family setting on earth.

We all became captivated by the storybook romance of Prince Charles and Princess Diana. Theirs was billed as "the wedding of the century" as a world looked on the enchanting love story of a gallant prince named Charles and his golden-haired Lady Diana. The grand moment came with the arrival of newborn Prince William, heir to the throne of Great Britain who will be bred to carry on the proud traditions of his homeland. Of Prince William, it was said, he was "Born to be king." Jesus, above all others of history, was born to be King.

This title, and its context speaks to us of the royal family of Israel. Christ was a descendant of the royal line of David and Israel's kings. However, He transcended all the royalty that was represented in the title. The glory of His regal splendor pales into insignificance the smoking flax of earth's kings. He brought a glory and a grandeur to the throne of David that will be undimmed and undiminished throughout eternal ages. Time is but His courier and eternity His habitation in contrast to the ephemeral reigns of earth's monarchs.

He who is the Son of God became the Son of David, that we might be of His spiritual lineage and be forever adopted as sons of God.

Christ of infinite love, I thank You for making it possible for me to be born into the great family of our Heavenly Father. Enable me to ever be His faithful and loving child.

Portrait Nineteen
BRANCH

A shoot will come up from the stump of Jesse; from his roots a Branch will bear fruit (Isa. 11:1).

Jesse was a father of kings. David, Solomon, Hezekiah, and Josiah came from his lineage, but now the kingly line was as a truncated tree. Isaiah was prophesying that from that stump would grow a Stem and a Branch that would become greater than all that grew before it.

God would keep alive the roots of the family tree of Jesse as revealed in the intriguing genealogies of Matthew and Luke.

This verse reveals Christ's inseparable link with history. History is subject to God's sovereignty. The perfectly synchronized events surrounding the birth of Christ dramatically illustrate this text. Christ's birth in Bethlehem was no geographical happenstance. The location had been prophesied centuries before by Micah. But Mary and Joseph lived in Nazareth! Enter Caesar Augustus with his required census when Mary was almost "term" in her pregnancy and the holy family had to travel to the city of Joseph's family origin to register. The name of that city? You can find it in the Old Testament Book of Micah!

The Gospel would have to be communicated throughout the world. It was a far cry in that day from the "global village" of our time. Diversities of language, divisions among nations, and distances seemed to preclude such a proclamation. Enter Alexander the Great. He gave the world of his day a universal

language—Greek—that would facilitate the disseminationof the evangel.

Roads were needed to carry the message beyond the parochial confines of Palestine. Enter the Caesars and the vast network of roads of the Roman Empire.

The birth of Christ at this most fortuitous period was no historical coincidence. Great movements and events were orchestrated for that moment of time on the stage of history.

His birth of the lineage of Jesse was no genealogical accident. *"There shall come forth."* History has certain predictable elements as it falls under the sovereignty of God. There are junctures at which God intervenes.

In the cataclysmic events of our day, it is greatly reassuring that God overrules history. Those who today would publish the obituary of God would do well to ponder the divine thread that is interwoven with the ages. It has not been severed in this so-called postmodern world. God is still on the throne.

Not only does this title suggest Christ's link with history in His invincible sovereignty over its course, but it would remind us of His superiority over earth's monarchs. The other kings of David's line have been buried in the sands of time. Their empires have vanished. Their gold tarnished and their influence spent its little day. All other rulers pale into insignificance next to His transcendent splendor. His is an unapproachable glory, an unexampled sublimity, an ineffable majesty.

This *Branch* that shall grow out of the "stump of Jesse," will bring bounty and blessing unknown under any other king. Isaiah goes on to prophesy: "In that day the Root of Jesse will stand as a banner for the peoples; the nations will rally to Him, and His place of rest will be glorious" (11:10). The prophet declares His coming will be cause for exaltation: "In that day you will say. . . . 'The Lord, the Lord, is my strength and my song; He has become my salvation.' With joy you will draw water from the wells of salvation" (12:1-3). May this joy be ours.

Christ, center and sovereign of history, rule over my life, my will, my future.

Portrait Twenty
ARM OF THE LORD

To whom has the arm of the Lord been revealed? (Isa. 53:1)

Isaiah, in the chapter that speaks of the sacrifice of Christ more eloquently than any other in the Old Testament, exclaims: "Who has believed our message and to whom has the arm of the Lord been revealed?" (53:1) "Arm" was a figure of speech for power, decisive action. Christ was the decisive action of the Eternal to bring deliverance and salvation, sublimely described in the remainder of this chapter.

The word "revealed" indicates that He had been hidden. For centuries, the prophets and people of God had been standing on tiptoe, awaiting the promised Messiah. Then, in the event of the ages, in that miracle and marvel of the manger in Bethlehem, the arm of the Lord became revealed. That rough-hewn manger cradled the destiny of man and his hopes of all the years. It was the moment of God's supreme revelation.

The Emperor Constantine built a church over the cave believed to have been the birthplace of Christ. As you descend into that cave of the Nativity, now under the high altar of the church, the opening is such that you must stoop or kneel to enter. In the floor there is a star, and around it the Latin inscription: "Here Jesus Christ was born of the Virgin Mary." There is something beautifully symbolic that the pilgrim has to kneel to enter the birthplace of our Lord, for to contemplate His birth fills the soul with awe and reverence. We stand before the miracle of the God of Creation, whose power is

flaunted by orbiting spheres, unveiling Himself and revealing His love in a Babe!

But the arm of the Lord was further revealed—in His magnificent life, His suffering and death, the triumph of His resurrection and ascension. Still He is being revealed by the Holy Spirit to His followers. And, someday, He will reveal Himself again in His mighty return.

Who has believed the message? To whom is the arm of the Lord revealed? Just think—you and me!

Heavenly Father, thank You for the love that brought Christ to earth and went all the way to Calvary for me.

Portrait Twenty-One
OFFSPRING OF THE WOMAN

And I will put enmity . . . between your offspring and hers;
He will crush your head, and you will strike His heel
(Gen. 3:15).

The only Utopia ever known to man on earth was the idyllic setting of the Garden of Eden. There Adam and Eve basked in perfect bliss and splendor. They had beauty, peace, perfection of body and mind, and a sense of divine presence. They were a fresh thought from the mind of God. They were a fresh breath from the Spirit of God. They were made in the very likeness of their Creator.

They had everything going for them. Then suddenly—disaster! The Fall! By disbelief and disobedience, they fell from their pinnacle of paradise. The sky blackened over their lives. They became sinners, transgressors against their mighty and loving Creator. The venom of sin entered the bloodstream of humanity. Paradise became lost. The sentence of death was pronounced.

Suddenly in that awful dark sky there appeared the twinkling of a star—the star of prophetical promise. There is the promise of the Offspring of the woman. God's creation would not be aborted. There would come from that Offspring the conquest of Satan and sin.

God, speaking to Satan at the Fall, says of the One promised as Offspring of the woman, "He will crush your head." Satan will be dealt a deathblow. But the Promised One will be wounded in the battle: "You will strike His heel." The destruction of Satan and temporary wounding of the Promised One is

dramatically contrasted between the blow to the "head" and the "heel." The Offspring of the woman will be "wounded for our transgressions" and "bruised for our iniquities," but He will recover and reign forever.

The "Offspring of the woman" was the first messianic reference and promise given to man. It was the lone star on man's horizon in the dawn of Creation by which he would steer his frail bark of life toward a haven of hope. It was the first title of a promised Deliverer from the Fall and its consequences. It prophesied His victorious battle on behalf of creation.

This title also suggests, and many scholars believe it prophesies, the virgin birth of Jesus Christ. In the Old Testament, genealogy is reckoned through the man and not the woman. This reference to Christ being the offspring of a woman is in keeping with the fact that He would not have earthly paternity.

The doctrine of the Virgin Birth has been a battlefield of theological controversy through the years. Biologically, a virgin birth is an impossibility, but so was the raising of Lazarus and the Resurrection. Someone has stated, "The presence of mystery is the footprint of the Divine." In harmony with God's miraculous power, the Virgin Birth would be but one of a chain of supernatural events in the marvelous life and mission of our Lord.

We are reminded each Advent season of this stupendous truth when we hear the words of Charles Wesley:

> Christ, by highest heaven adored,
> Christ, the everlasting Lord,
> Late in time behold Him come,
> Offspring of a virgin's womb.
> Veiled in flesh the Godhead see;
> Hail the incarnate Deity!
> Pleased as Man with man to dwell,
> Jesus, our Immanuel.

Lord, I am awed by the mystery that from the dawn of Creation, You gave the promise and provision for our redemption from the Fall. Such a divine love overwhelms me!

Portrait Twenty-Two
BABY

*You will find a Baby wrapped in cloths and lying in a manger
(Luke 2:12).*

Who art Thou there?
O Babe, that whimpers in the hay,
And cuddles in a mother's arm!
Art Thou the God who made the worlds?
And flung afar the Milky Way?
And holds them all by naked word?
Art Thou that God?

ANONYMOUS

How stupendous that God would come to earth as a Baby! In that Babe of Bethlehem lies the destiny of mankind.

God lay a Baby on the doorstep of the world. He was born, not in a palace, but in a cattle barn; not on the famed Appian Way, but in an obscure hamlet. A feeding trough was His cradle and beasts of the field and lowly shepherds were His attendants. He was born, not of royalty, but of humble and poor parents.

Yet an angelic chorus heralded His birth. A star led wise men on a long pilgrimage to the very place where He was. The Emperor Augustus is best known for his brief relationship with that stable. Such are the mysterious and mighty ways of God.

For the birth of that Baby was the colossal event of the ages. No army that ever marched, no battle ever fought, no discovery ever made, no other event of history begins to match

that moment for its impact on the world and its import for eternity.

Joni Eareckson Tada shares her sense of marvel as a high school student in singing of His birth: "When I was in high school back in the late '60s, I was a part of our high school choir and I remember singing Handel's *Messiah* for one of our Christmas programs. I can still recall so vividly the deep joy I felt in singing that beautiful chorus, 'For unto us a Child is born.' I was just a kid, but tears really came to my eyes as we sang. 'And His name shall be called, Wonderful, Counselor, the Mighty God, the Everlasting Father, the Prince of Peace.' . . . It was to be years later that I would ascribe to Christ personally all those magnificent titles. . . . Can you imagine a tiny little Baby called, not simply, Wonderful—as many babies will be called. But a Baby called Counselor, the Mighty God, even. A small Infant called the Everlasting Father and Prince of Peace. He's all these things." (Used with permission of JONI AND FRIENDS.)

Yes, that Baby of Bethlehem was all those things in fulfillment of the centuries-old prophecy of Isaiah. And that Baby, who grew to manhood, and was flung on a felon's cross, and rose from the dead, and today is at the right hand of God—wants to be born in each of our hearts and lives.

> Though Christ a thousand times
> In Bethlehem be born,
> If He's not born in you,
> Your soul is still forlorn.
>
> Ah, would your heart but be
> A manger for His birth,
> Once more would God now come
> With peace upon the earth.
> AUTHOR UNKNOWN

Dear Lord, who came as a Baby at Bethlehem, may my heart be a cradle for Your birth and a dwelling for Your presence.

Portrait Twenty-Three
JESUS

You are to give Him the name Jesus, because He will save His people from their sins (Matt.1:21).

Our verse starts with a *declaration*, "You are to give." The name *Jesus* was the name God Himself chose. God sent His own messenger from the heavenly courts and through the celestial corridors to announce what His name should be.

Then there is the *designation*, "Jesus." It is the name by which we know Him best. It is His earthly name. Other names and titles were ascribed to Him in special ways and for a specific purpose, but this is His primary name. In the Gospels, He is called by this name over 500 times, with the name occurring 909 times in the New Testament.

Of all the names and titles of Christ this is the one that has been most endearing to His followers. The contents of a hymn-book add eloquent testimony of that fact: John Newton gave us, "How sweet the name of Jesus sounds"; Edward Perronet exalts this name with, "All hail the power of Jesus' name!" Bernard leads us to devotional depths with his, "Jesus! the very thought of Thee"; Baxter earnestly enjoins, "Take the name of Jesus with you"; Frederick Whitfield exclaims, "There is a name I love to hear."

Our text gives the *denotation* of this name—"He shall save His people from their sins." It is the name that denotes the great purpose of His life. Above all else He came to be our Saviour. Imagine knowing Tennyson, but not as a poet; Shakespeare, but not as a litterateur; Socrates, but not as a philoso-

pher! Unless we know Jesus as Saviour, we miss the preeminent message and mission of His life.

The names *Jesus* and *Joshua* are the same. *Joshua* is the Hebrew equivalent of the Greek *Jesus*. Many Bible scholars consider Joshua to have been a prototype of Christ. There are striking points of correspondency between the type and the prototype. Joshua led the Israelites from the wilderness to the Promised Land. Jesus as Saviour brings us from the wilderness of sin into our spiritual Promised Land. Joshua led his people to conquests over their enemies with their walled cities and tall giants. Jesus leads us to conquest over the enemies of our soul. He enables us to fight victoriously against life's difficult obstacles and its giants of temptation, trial, and testing. As our Joshua, He leads us to the inheritance God has for us—a land spiritually "flowing with milk and honey."

Jesus, of course, far transcended Joshua's work of salvation among the people. Joshua's deliverance foreshadowed and prefigured the One who would give ultimate fulfillment to this great name. The Scriptures declare: "Salvation is found in no one else, for there is no other name under heaven given to men by which we must be saved" (Acts 4:12).

With Will J. Brand, we would exultantly sing:

> There is beauty in the name of Jesus,
> Passing time can ne'er extol;
> All the splendor of its clear unfolding
> Will eternal years enroll.
>
> There's salvation in the name of Jesus;
> Trusting in His name alone
> We shall find ourselves at last presented
> Faultless at His Father's throne.
>
> There is rapture in the name of Jesus,
> Joy that bears the soul above,
> All the wealth of heaven to earth restoring,
> Name of all-redeeming love.

Jesus, You are a mighty Saviour. I have come to You for there is no one else to whom I can go for my salvation and security.

Portrait Twenty-Four
IMMANUEL

"The virgin will be with child and will give birth to a Son, and they will call Him Immanuel"—which means, "God with us" (Matt. 1:23).

God had this name written three times in His Word: Isaiah 7:14; 8:8; and in our text. In the Gospel account, the angel in his announcement to Joseph is quoting the Prophet Isaiah.

Christ alone was great enough to be called Immanuel. No one else could fill its glowing meaning—*God with us.*

John gives us a graphic portrait of Christ among us when he wrote that He "became flesh (human, incarnate), and tabernacled—fixed His tent of flesh, lived awhile—among us; and we [actually] saw His glory" (John 1:14, AMP). This thought of God fixing His tent of flesh and living among us is a stupendous one. It is almost inconceivable. It staggers the imagination. Yet that is precisely what happened with the Incarnation.

The miracle and the marvel of *Immanuel*—God with us— defies description. The hands of God that had tumbled solar systems into space became the small chubby hands of an Infant. The feet of God that had roamed through fiery planets became the infant feet of a Baby. Jesus was the heart of God wrapped in human flesh. He was God in the garb of humanity. He was God walking the earth in sandals.

From that feeding trough in the cattle shed of lowly Bethlehem, the cry from that Infant's throat broke through the silence of centuries. For the first time on Planet Earth, there was heard the voice of God from human vocal chords. *Immanuel* speaks to us of the mighty miracle and marvel of God

becoming Man and dwelling with us.

A young child looked at a picture of her absent father and longingly said, "I wish Father would step out of that picture." For centuries, men had a yearning for God to step out of the picture—to become more real, more tangible to man. Men wanted to know God better, what He was like, and to commune with Him. At Bethlehem, God became flesh—became real, understandable to men. Jesus was God's authentic self-disclosure.

What a reassuring thought it is that He is still *Immanuel* to His followers. He is still *God with us*. He has promised, "Surely I will be with you always, to the very end of the age" (Matt. 28:20). We follow the One who said, "Never will I leave you; never will I forsake you" (Heb. 13:5). He is always the contemporary Christ. He is superior to all life's vicissitudes, surviving death itself. He will walk with us through its valley into the house of the Lord where we shall dwell with Him forever.

Immanuel, abide with me all through life. Thus, enriched by Your fellowship, strengthened by Your presence, and led by Your guidance, I shall be able to walk life's path victoriously.

Portrait Twenty-Five
HOLY ONE

I know who You are—the Holy One of God! (Mark 1:24)

Jesus was known as "the Holy One" or "consecrated One."
Peter, in his Pentecost sermon, spoke of Christ as the *Holy One* (Acts 2:27), as did Paul in his preaching (13:35). Jesus identified Himself as "Him who is holy" (Rev. 3:7). He was born without sin and lived a sinless and perfectly holy life. Holiness is one of His divine attributes.

When making our literary pilgrimage to Stratford-on-Avon, we saw inscribed on a commemorative medallion at Shakespeare's birthplace, these words for his quadricentennial: "1564-1964—We shall not look upon his like again." In a literary sense, that is true. Shakespeare is *sui generis*—one of a kind. In the spiritual realm, our Lord Jesus Christ is one of a kind. His holiness is unapproachable, not only above men, but also above saints and seraphs, above angels and archangels. This truth is enshrined in Tennyson's poem:

> Strong Son of God, immortal love,
> Whom we, that have not seen Thy face,
> By faith, and faith alone, embrace,
> Believing where we cannot prove.
> Thou seemest human and divine,
> The highest, holiest manhood, Thou;
> Our wills are ours, to make them Thine.

Holy Christ, help me to be a "partaker of Your divine nature."

Portrait Twenty-Six
THE BOY JESUS

The Boy Jesus stayed behind in Jerusalem (Luke 2:43).

From the time of our Lord's birth and the flight to Egypt, until the beginning of His ministry when He was 30 years of age, there is that long interval comprising almost all of His life, known as the silent years. There is one window into those years—it was when Jesus was 12 years old and His parents made their annual pilgrimage to Jerusalem for the Feast of the Passover. Returning home with their caravan, they discovered "the Boy Jesus stayed behind in Jerusalem, but they were unaware of it. Thinking He was in their company, they traveled on for a day. They then began looking for Him among their relatives and friends. When they did not find Him, they went back to Jerusalem to look for Him. After three days they found Him in the temple courts, sitting among the teachers, listening to them and asking them questions. Everyone who heard Him was amazed at His understanding and His answers" (Luke 2:43-47).

This intriguing and singular portrait of the boyhood of Jesus is pregnant with insight. It reveals His extraordinary wisdom and understanding even at this young age. "Amazed" is the word used of the learned men with whom He discoursed. "Astonished" were His parents at this evidence of His precosity. The Boy Jesus further reveals His own sense of destiny in His response to His parents' anxiety: "Didn't you know I had to be in My Father's house?" (v. 49) There is the

intriguing remark that "His mother treasured all these things
in her heart" (v. 51). And the statement that Jesus, returning
with His parents to Nazareth, "was obedient to them" (v. 51).

This illuminating episode culminates with the statement:
"And Jesus grew in wisdom and stature, and in favor with
God and men" (v. 52). This portrait of the young manhood of
Jesus becomes a model for the development of every life. Jesus
grew in wisdom—intellectual growth; in stature—physical de-
velopment; in favor with God—spiritual maturing; and in fa-
vor with men—social development.

Artist Warner Sallman has given us a striking portrait of the
Boy Christ. It is replete with symbolic details that speak of His
coming ministry and sacrifice. There is in the background a city
on a hill that would find a place in His teaching, a deer panting
after the water brook that speaks of His offering the living
water, sheep on the hillside without a shepherd, and the Boy
Christ holding a sheep. The artist has Him seated in front of a
large rock. If you look carefully, you will note the subtle
shadow of a cross on the rock, symbolizing that the shadow of
the cross loomed over the early life of our Lord.

Poet Catherine Baird has eloquently given expression to our
imagination of the youth of Jesus:

> When Jesus looked o'er Galilee,
> So blue and calm and fair,
> Upon her bosom, could He see
> A cross reflected there?
>
> When sunrise dyed the lovely deeps,
> And sparkled in His hair,
> O did the light rays seem to say:
> A crown of thorns He'll wear?
>
> But when the winds triumphantly
> Swept from the open plain,
> The Master surely heard the song:
> The Lord shall live again!

*Dear Jesus, help me to realize the full potential of my life, in-
cluding a vulnerable discipleship.*

Portrait Twenty-Seven
BROTHER

*Isn't this Mary's Son and the Brother of James, Joses, Judas
and Simon? Aren't His sisters here with us? (Mark 6:3)*

There were at least six siblings who knew Jesus as Brother in
their humble home in Nazareth. Jesus no doubt often played
the elder Brother's part. James, Joses, Judas, Simon, and the
sisters would often be helped by their older Brother Jesus. It
was He who would shepherd them through the busy streets
and keep them from the danger of racing chariots. He would
run errands for His mother. There was water to be brought
from a well or a message to take to a neighbor.

Then there was that desolate day when He, as the older
Brother, put His strong arms around His mother Mary, as
Joseph the good father of that family was laid to rest. As the
elder Brother, He stepped into the work of the carpenter's
shop and supported the family by the trade He had learned at
His father's side. Jesus was a loving and faithful Brother.

But there is an incident in the Gospels that invests this title
with deep spiritual meaning. We read: "While Jesus was still
talking to the crowd, His mother and brothers stood outside,
wanting to speak to Him. . . . Pointing to His disciples, He
said, 'Here are My mother and My brothers. For whoever does
the will of My Father in heaven is My brother and sister and
mother' " (Matt. 12:46-50). To every believer, Jesus is the Elder
Brother.

A newspaper told the story of a truck driver caught in a
roaring blizzard. His wife had begged him not to make the run

that night, for there was forecast a snowstorm of major propor-
tions. But he had a load to deliver and he went anyway.
Enroute, the howling storm swept down on him. Driving
became impossible. He pulled the big truck off the road and
went to sleep. When he awoke, everything was dark. He was
buried in a snowdrift 30 feet deep. No part of his truck was
visible from the highway. He could not open the doors. He
was trapped. For five days and nights he stayed in his icy
tomb. He had no food. He ate snow to quench his thirst. Five
days and nights. But he didn't panic. He waited, calmly and
stoically, to be rescued; and finally he was. When asked if he
were afraid, he answered, "No. I knew my brother would be
looking for me. I knew he would not rest until he found me. In
my mind I could see him searching, searching, never giving
up." The story powerfully illustrates the text from Proverbs:
"A brother is born for adversity" (17:17). How blessed is one
who has such a brother; by blood, or by spiritual bond. The
friendship of Jesus is the highest privilege and greatest bless-
ing of life.

It seems no one of the myriad titles of our Lord is without
incorporation in our hymns. This one is no exception. In the
third verse of Henry Van Dyke's familiar "Joyful, Joyful, We
Adore Thee" sung to the melody of Beethoven's *Ninth Sympho-
ny*, is found this title of our Lord:

Thou art giving and forgiving, Ever blessing, ever blest,
Wellspring of the joy of living, Ocean depth of happy rest!
Thou our Father Christ, our Brother—All who live in love
are Thine;
Teach us how to love each other; Lift us to the joy divine.

*Thank You, Lord, for this special relationship we are privi-
leged to have with You as our Brother.*

Portrait Twenty-Eight
NAZARENE

And He went and lived in a town called Nazareth. So was ful-
filled what was said through the prophets: "He will be called a
Nazarene" (Matt. 2:23).

This title of Christ is derived from the small village where He
lived during those silent years. The village of Nazareth was
quite insignificant. It is not mentioned with other cities in the
ancient records of writers. We recall Nathanael's reply of incre-
dulity when Philip told him that the Messiah had come from
Nazareth, "Can anything good come from there?" (John 1:46)
Thus was Nazareth thought of and spoken of with contempt.
That is, until Jesus changed all that.

In this somewhat obscure village, Jesus grew up. There were
brothers and sisters in the home. Jesus played the older Broth-
er's part.

Christ as the Nazarene lived in a humble home, did the
manual work of a carpenter, and mingled in the busy mart and
everyday life of the people. There are many to whom this
warm portrait of the Master gives comfort and reassurance.

Important caravan routes came through the vicinity of Naza-
reth. The village residents would witness the throngs of pil-
grims on the road from Jerusalem, the wealthy merchants
coming up from Egypt, the caravans of the Midianites with
their interesting wares. These travelers would echo the news
of the world. As Christ grew, He was exposed and sensitized
to the busy commerce of life. Though Nazareth was not a
notable town it was strategically placed amidst the traffic of life
in that day. A boy growing up there could see and hear and

sense the pulse of the Eastern world.

Nazareth was just a hamlet, obscure and insignificant until Jesus came and made His home there. His presence has a transforming influence on all that comes in close contact with Him. So too if we will invite Him to come and make His abode in our lives, He will transform our common lives to ones with eternal meaning and purpose. The devotional words of Stanley Ditmer's song "The Nazarene," beautifully describe this truth:

> I never knew how poor was my condition,
> For I was blind, and all my need unseen;
> Until one day in my unworthy station,
> I chanced to meet the lowly Nazarene.
>
> It was His life that purchased my salvation;
> It was His grace that set my spirit free.
> It is His blood that seals my consecration;
> It is His love that intercedes for me.
>
> My finite mind will never cease to wonder
> Why Jesus should my sinful heart entreat;
> Nor do I even dare to stop and ponder,
> But kneel in penitence before His feet.

Christ, who experienced the common things of humanity, take the drab and broken threads of my everyday life and with the skill of Your hands weave them into a tapestry of beauty for eternity.

Portrait Twenty-Nine
CARPENTER

Isn't this the carpenter? (Mark 6:3)

The New Testament word for "carpenter" is the word *tekton* which means an artisan, a craftsman, or one who is a builder.

The Scriptures reveal Christ as Carpenter of the universe: "Through Him all things were made; without Him nothing was made that has been made" (John 1:3). The hands that held the hammer and worked the saw here on earth were hands that carpentered the fathomless galaxies and the infinite depths of Creation. Those hands that shaved and smoothed the wood at the carpenter's bench in Nazareth also created the stars and the planets with their perfect design and precision.

The cosmic Carpenter by the miracle of Incarnation became the Carpenter of Nazareth. The question of our text asked by the disaffected Nazarenes on that Sabbath Day is the only window in the Scriptures through which we may look on the years of His young manhood. These few words speak volumes to us about the silent years. This portrait of our Lord as a Carpenter suggests many things that would characterize His daily round of toil.

The absence of Joseph from the later Gospel narratives seems to suggest that the wise and humble father of that family had been laid to rest, and Jesus, as the elder Brother, took over the support of the family by the trade He had mastered in His father's shop. Then finally, when the other

brothers and sisters were old enough, He made His last yoke. After shaking the wood shavings from His tunic for the last time, He went out to build the eternal kingdom of God in the hearts of men.

G.A. Studdert-Kennedy has framed this portrait of our Lord in memorable verse, titled, "The Carpenter":

> I wonder what He charged for chairs at Nazareth.
> And did men try to beat Him down
> And boast about it in the town—
> "I bought it cheap for half-a-crown
> From that mad Carpenter"?
>
> I wonder did He have bad debts,
> And did He know my fears and frets?
> The Gospel writer here forgets
> To tell about the Carpenter.*

This portrait of Christ as a Carpenter identifies Him with mankind. How reassuring it is to know that He who now holds a scepter in His hand once held a hammer and a saw. It is a vivid portrait of the manhood of Jesus Christ. Often His hands would be bruised and torn by the grain. As He worked day after day, making the wood obedient to His skill, His hands became as strong as a vise. They became roughened and callused, the kind of hands strong fishermen would look at and know that they could follow Him with confidence and respect. He knew the meaning of toil. He understands our burdens, our weariness, our tasks.

As the Carpenter, Christ forever sanctified human toil. We are all members of the corporate society. As we derive many benefits, so must we be contributive to the community. Our tasks are given dignity by the One who worked amid the wood shavings at the carpenter's bench for the greater part of His life. His labor enabled the oxen to plow without being chafed by their yokes, children to take delight in the hand-carved toys, families to live in the comfort of a home built by the Carpenter.

*From *1,000 Quotable Poems*, compiled by Thomas Clark. © 1937, Willett, Clark and Co. Reprinted 1973 by Harper and Row.

Today, the Carpenter of Nazareth who once smoothed yokes in His skillful hands, would take a life that is yielded to Him and fashion it into a beautiful and useful instrument of God's eternal kingdom.

Carpenter of Nazareth, take my life and smooth the coarseness of its grain, work out the flaws and imperfections, make me a worthwhile and useful instrument for the kingdom.

Portrait Thirty
JEW

The Samaritan woman said to Him, "You are a Jew" (John 4:9).

Christ could have been born a Roman. The greatest claim that could be made in His day was *"Civus Romanus sum!"*—"I am a Roman citizen." Rome ruled the world and to be a Roman citizen was to enjoy the greatest privileges and protection of the empire.

Or Christ could have been born a Greek and be identified with the race that gave the world its rich aesthetics and literary legacy. In fact, though Rome conquered Greece, the Greek language conquered the world and became the universal language.

But Christ did not choose to be identified with, in Poe's words, "The glory that was Greece, and the grandeur that was Rome." Rather He chose to become a member of the most downtrodden and despised race of His day, and of all history—the Jews. The woman of Samaria, whom Jesus approached at the well, was citing the bitter animosity between her race and the Jews when she said to Christ, "You are a Jew" (John 4:9). Anti-Semitism has never ceased, with our own day witnessing the unspeakable horrors of the holocaust.

Jesus was a Jew. He identified with the race that has suffered most throughout history. But it also has been the race that God has singularly chosen and blessed and through whom He has given us the riches of the Old Testament and the supreme blessing of the Messiah.

81

Sholem Asch writes of his pride in being a Jew: "Jesus Christ is the outstanding personality of all time. . . . Is still a Teacher whose teaching is such a guidepost for the world we live in. . . . He became the Light of the World. Why shouldn't I, a Jew, be proud of that?"

Let us cease trying to anglo-saxonize Christ with blond hair, blue eyes, and white skin, and let Him be the Jew that He was, giving our respect to the race He so highly honored.

Heavenly Father, thank You for the Jewish race that has given us so much of Your precious Living Word.

Portrait Thirty-One
GALILEAN

Pilate asked if the man was a Galilean (Luke 23:6).

Jesus was accused by the Jews of the most serious crime in the empire—rebellion. Pilate, before whom Jesus stood in judgment, fearful the Jews might accuse him to Caesar of taking an insurgent under his protection, asked if Jesus was a Galilean. Confirming that He was gave Pilate his opportunity to turn this knotty and dangerous problem over to Herod who was in charge of the Galilee province. Galilee was the region of north Palestine where Jesus spent His boyhood and early ministry.

Galilee was not a rural backwater but was traversed by some of the major routes of the empire. God cast it geographically at one of the most strategic crossroads of the world. When our Israeli guide in Palestine was asked which continent Israel is in, he replied that an Israeli can claim to be a dweller of three continents for Israel is a land bridge connecting Africa, Asia, and Europe. The plain of Esdraelon, known as the Valley of Armageddon, was blood-soaked by the armies that have marched over it for thousands of years. Through this fertile valley marched the Egyptians, Philistines, Assyrians, Persians, Greeks, Romans, Crusaders, Turks, and British. The fortress of Megiddo that guards the pass of the Valley and is known as the "Gibraltar of Palestine," has felt the tremors of Alexander the Great in his pursuit of world conquest, the legions of Vespasian, the cavalries of Napoleon en route to his embarrassment at Acre. More recently, it witnessed the unresisted

advance of the British under Allenby in 1917 and the rumbling of Jewish tanks in the June 6, 1967 war. And, according to Bible prophecy, it isn't over yet.

The crown jewel of the province of Galilee is Israel's only freshwater lake, the Sea of Galilee, framed by the hills and pastoral scenes of the region. So much of the ministry of our Lord transpired around its pebbled shores and sparkling blue waters. When in Israel, several mornings I went alone before dawn down by the shore of the Sea of Galilee to meditate. In such moments, one's soul becomes hushed. All that impinged on the senses were His experiences in predawn communication with His Father. Whittier's words come to mind:

> O Sabbath rest by Galilee!
> O calm of hills above,
> Where Jesus knelt to share with Thee
> The silence of eternity,
> Interpreted by love!

The land of the Lord is closely intertwined with the Lord of the land. He strode its dusty roads, climbed its hills, spent many hours by and on its waters, knew the solitude of its mountains and the bustle of its marketplace. He derived from its rustic regions a replenishment for His soul and as He mingled at the crossroads of the world, gave us His universal salvation.

The devotional expression and prayer of the late Commissioner Robert Hoggard is addressed to the Man of Galilee:

> Saviour of light, I look just now to Thee;
> Brighten my path, so only shall I see
> Thy footprints, Lord, which mark the way for me;
> Light of my life, so surely Thou wilt be,
> O Man of Galilee

> *In the words of the chorus of this verse, I would pray; O Man of Galilee, Stay with and strengthen me; Walk Thou through life with me, O Man of Galilee!*

Portrait Thirty-Two
THE MAN

The Man Christ Jesus, who gave Himself as a ransom for all men (1 Tim. 2:5-6).

Peter, preaching at Pentecost, declared "Jesus of Nazareth was a Man" (Acts 2:22). Paul, writing of the mighty transition from God to man, affirms that Christ was "made in human likeness" and was "found in appearance as a Man" (Phil. 2:7-8). Pilate, at the trial of our Lord, echoed this truth when he presented Jesus before the mob with the words, "Here is the Man" (John 19:5).

In our text, Paul adds credibility to Christ's role as Mediator by stating He was both God and man (1 Tim. 2:5-6). Thus our Lord could represent God and man, having both natures.

Christ is called "the Man" in Scripture to emphasize the fact of His humanity. He who was divine, became human. He who was God, became man. He who was infinite, became finite. He who was Spirit, became flesh. He who was with all the attributes of divinity, took upon Himself the limitations of our humanity. The Incarnation, God becoming man, is in the words of C.S. Lewis "the grand miracle."

In our veneration of Christ, let us not lose sight that He was a Man, human as we are. Let us not wrap Him in the mist of the years or veil Him in the mysticism of our creeds.

For Christ Jesus was a Man. And what a Man!

Christ of our human road, thank You because You have walked our way and known our struggles and sorrows.

Portrait Thirty-Three
SON OF MAN

Just as the Son of Man did not come to be served, but to serve,
and to give His life as a ransom for many (Matt. 20:28).

Jesus selected this title for Himself, it being recorded about 80 times in the Gospels. No one else ever directly addressed Him by this title. It has its origin in the messianic passage of Daniel 7:13: "In my vision at night I looked, and there before me was one like a Son of Man, coming with the clouds of heaven."

This title speaks of the humanity of Jesus Christ. He was God clothed in the garb of humanity. What unfathomable love! What condescension that God should take on Himself the frailty and the limitation of man! The One who had spoken oceans into existence became a Man and asked an outcast for a drink.

Pilate did not subscribe to the divinity of Christ. He could not perceive the divine qualities of the One who stood before him in his judgment hall. But there was something about this Person that stirred his soul. He could not but see how heroically Christ endured His torments. He saw, as he had never seen before, ignominy met with dignity, vehemence and brutality met with unruffled composure, excruciating torture of the lashes with the dreaded Roman cat-o'-nine-tails met with courage and without vengeful spirit. Yes, there was something more than ordinary about this regal figure who stood before him. And, though he did not ascribe divinity to Him, he was compelled to declare before the seething mob, *Ecce Homo* — translated from the Latin, "Here is the Man." His Roman ideal

of manhood was met in Christ. With lashing irony calculated to sting the bigoted mob calling for His death, he pays Jesus this tribute, acclaiming Him as every inch a man. It is as though he said, "Among all you Jews, at last I have come upon a real man as a Roman thinks of men."

At the Pitti Art Gallery in Florence, Italy a guide was comparing portrait paintings of the Renaissance. Pointing to one that was unobscured by extraneous detail, she said, "Now this portrait looks as though you can converse with Him." When leaving Florence, a woman on the train remarked to us, "Christ and the Apostles seem so much more real since I've seen these pictures." This portrait of Christ as the Son of Man makes Him real to our understanding. He steps out of the pages of the New Testament as One who entered into the common lot of our humanity. We see Him weary, hungry, thirsting, laughing, conversing, weeping, suffering, dying.

This title is associated not only with the humanity of Jesus Christ but with His divinity as well. We cannot neatly compartmentalize His humanity. He was a mysterious and majestic composite of man and God. This title is linked with some of the sublime declarations of Christ. Among them:

"When the Son of Man comes in His glory, and all the angels with Him, He will sit on His throne in heavenly glory. All the nations will be gathered before Him, and He will separate the people one from another" (Matt. 25:31-32). "In the future you will see the Son of Man sitting at the right hand of the Mighty One and coming on the clouds of heaven" (Matt. 26:64; Mark 14:62; see Luke 22:69).

Our text at the beginning reminds us of Christ's mission as the Son of Man. It was a role assumed to serve (to minister), to suffer (give His life), and to save (ransom for many). The Son of God became the Son of Man that we might become sons of God.

Christ, who became the Son of Man, walk with me and help me in my humanity to ever be linked with Your divinity.

Portrait Thirty-Four
PROPHET

The crowds answered, "This is Jesus, the Prophet from Naza-
reth in Galilee" (Matt. 21:11).

To the devout believer of biblical days, prophets were of the
highest rank and order among men. When awed by His mir-
acles or witnessing a demonstration of His deep wisdom or
great power, people often acclaimed Him a prophet. It was the
highest compliment that could be given to a man.

A prophet was specially chosen and anointed by God. God
vouchsafed His message to man through the prophets. The
prophet was God's mouthpiece. He had two primary func-
tions: He foretold the future and he forthtold God's message to
man.

Each prophet of the Old Testament gave some new insight
concerning God. Isaiah's sublime passages reveal God's
holiness and give incomparable predictions of the coming
Messiah. Jeremiah reveals the significance of personal religion.
Ezekiel depicts God's special relationship with Israel. Daniel
grasped the concept of God's sovereignty. Through Hosea,
God bares His heart of forgiveness for the backslider. Amos
thundered God's declarations for the application of religion to
the ills of society, to mention but a few.

Each prophet, out of his own life and experience, expressed
a fragment, a facet of truth about God. No prophet had
grasped the full contour of God's character and will. But Jesus,
as Prophet, revealed the full truth about God. He was Himself
a revelation of what God is like. He was the embodiment of

divine attributes. He alone could say, "He who has seen Me has seen the Father." He is the Prophet who gave us the complete and culminating revelation of God. He is the Prophet who gave, not a fragmentary knowledge, but a full disclosure of God.

Jesus supremely fulfills the office of a Prophet. His teachings and revealings were the culmination and the grand denouement of prophetical utterance. But Jesus was more than a prophet. He was the fulfillment of the prophecies that had gone before. Other prophets had been called and commissioned to prepare the way for Him. He was the Sun of Righteousness toward which all their flickering torches pointed. Viewing Christ as a prophet was a window through which we gain a greater and grander view of His nature and mission.

My reading experience was once greatly enriched by a biography of Tennyson with the noteworty title: *The Preeminent Victorian*. Other than Queen Victoria herself, no one else could be given that title. His life spanned almost all the Victorian Age. As Poet Laureate, he was the voice of that era. But there was a restrictive characteristic to that title. Tennyson belonged to his age. Christ belongs to the ages. Tennyson was considered preeminent for that period. Christ is the Preeminent One for all ages and eras. Compared to His brightness and glory all other prophets were as flashing meteorites which appeared briefly on the horizon and quickly burned themselves out. He transcends the prophets and fulfills their God-given oracles.

Preeminent Christ, rule and reign over all else in my heart and life.

Portrait Thirty-Five
TEACHER

*We know You are a Teacher who has come from God
(John 3:2).*

One of the most common portraits of Christ in the Gospels is that of Teacher. The Gospels are full of references to His teaching ministry. It is commonly reported that "Jesus went throughout Galilee, teaching in their synagogues" (Matt. 4:23). In the alfresco setting of a mountainside, Jesus taught His disciples and gave the world the "Sermon on the Mount" (Matt. 5–7).

On one occasion when the crowd that came to hear Him teach became too large, He "got into a boat and sat in it out on the lake, while all the people were along the shore at the water's edge. He taught them many things by parables" (Mark 4:1-2).

His "classrooms" were the synagogues, the mountainside, the lakeside, and in one-on-one encounters such as in His midnight interview with Nicodemus when He discoursed on the mystery and meaning of the new birth. Nicodemus, himself a member of the Sanhedrin and leader of the Jews, had discerned the extraordinary and superior character of the teaching of Jesus and yearned to learn from the Master. He acknowledged the more-than-human quality of Jesus' teaching as he addressed Christ, "We know You are a Teacher come from God" (John 3:2).

At the other end of the social and moral spectrum, we find Him giving His great dissertation on worship and living water

to a woman who had come to the well to draw water. In this instance, He not only crossed the boundary of respectability in conversing with a woman of unsavory character, but also of the racial polarization that existed between Jews and Samaritans. The school of Christ was without walls and boundaries of any kind.

The common impact on the hearers of Jesus' teaching was amazement at His wisdom and utterances. We find them exclaiming, "Where did this Man get these things? (Mark 6:2) What's this wisdom that has been given Him!" On another occasion, we read: "The crowds were amazed at His teaching, because He taught them as One who had authority" (Matt. 7:28-29).

When our Lord was arrested in the Garden of Gethsemane, He chided the mob: "Every day I sat in the temple courts teaching, and you did not arrest Me" (Matt. 26:55). One of the dominant portraits we have of Christ is that of Teacher.

As Teacher, He had none of the resources we have today— amplification, visuals, media, electronic aids. Yet, in marvelous tribute to His teaching, we have a substantive record of His discourses and teaching. Included in the account are 30 parables, where He painted word pictures so graphically that those who heard could never forget them.

What He taught has never become outdated but is as timely and timeless as when His words resonated throughout Galilee. All other learning and knowledge pale into insignificance compared to the eternal truths He imparted.

One of the great privileges of our Christian experience is to have the teachings of Jesus as recorded in the Gospels for our enlightenment and enrichment. Though we cannot step back into the time when Jesus cast His shadow on earth, we can, through the miracle of His Word and the ministry of the Holy Spirit, know and understand those timeless truths He taught during His sojourn here. May we who know Him as our Saviour and Lord also know Him as our Teacher. What incredible truths He has to share with us!

Divine Teacher, with the psalmist I would pray, "Teach me Your way, O Lord, and I will walk in Your truth" (Ps. 86:11).

Portrait Thirty-Six
PHYSICIAN

*Jesus said to them, "Surely you will quote this proverb to Me:
'Physician, heal yourself!' " (Luke 4:23)*

This is a title that Jesus gave Himself. It is one rich with meaning for many who have hurt and suffered and needed healing of the mind and spirit as well as the body.

Medical practice in the day of our Lord was primitive. There were no sterile operating rooms and trained doctors and nurses, no hospitals or hospices, no medical technology or research, no anesthesia. Pain and disease were often rampant.

The scriptural portrait of Christ as the Physician reveals not only His healing power but how He enters into our pain and suffering. He cares and is compassionate when we are hurting. His miracles of healing are numerous in the Gospels.

Matthew gives a beautiful and compassionate scene of our Lord: "When evening came, many who were demon-possessed were brought to Him, and He drove out the spirits with a word and healed all the sick" (8:16). Again, Matthew records: "Many followed Him, and He healed all their sick" (12:15). We turn the page of the Gospel and we find: "Great crowds came to Him, bringing the lame, the blind, the crippled, the dumb and many others, and laid them at His feet; and He healed them. The people were amazed when they saw the dumb speaking, the crippled made well, the lame walking and the blind seeing" (15:30-31). Matthew was constrained to keep returning to the healing scenes and ministry of the Master.

Doctor Luke could not but be impressed with the extensive

healing ministry of Christ. He records a vivid scene: "When the sun was setting, the people brought to Jesus all who had various kinds of sickness, and laying His hands on each one, He healed them" (4:40). The electrifying news of such healing miracles spread throughout the land as Luke tells us: "Yet the news about Him spread all the more, so that crowds of people came to hear Him and to be healed of their sicknesses" (5:15).

Luke, good doctor that he was, perceived the holistic practice of Christ. He records that to those He healed, Jesus said, "Your faith has healed you" (8:48). Only in the forgiveness and cleansing of sin can there be total healing.

It has been estimated that over half the people with illness are suffering from psychosomatic ailments, from the effects of the mind and spirit on the body. Dr. Jung, the famous psychiatrist, says: "About a third of my cases are suffering from no clinically definable neurosis, but from the senselessness and emptiness of their lives."

The healing ministry of Christ to all of us is His healing of our sins. "By His wounds you have been healed" (1 Peter 2:24). He is the Physician who took on Himself our fatal sickness.

Christ in the memorable words of T.S. Eliot from one of his *Four Quartets*, is the One who as:

> The wounded surgeon plies the steel
> That questions the distempered part;
> Beneath the bleeding hands we feel
> The sharp compassion of the healer's art
> Resolving the enigma of the fever chart.*

The good and the great Physician is the Wounded Surgeon who has felt our pain and known our sorrow and endured our suffering and wants to make us whole.

Good and Great Physician, touch me again that I may more fully know Your healing of body, mind, and soul.

* From "East Coker" in *Four Quartets* by T.S. Eliot, copyright 1943 by T.S. Eliot; renewed 1971 by Esme Valerie Eliot. Reprinted by permission of Harcourt Brace Jovanovich, Inc.

Portrait Thirty-Seven
SERVANT

Here is My Servant whom I have chosen (Matt. 12:18).

Imagine—the Sovereign of the universe—a Servant! What a peerless paradox! What consummate condescension! From what exalted heights to what unspeakable depths the Lord of the universe came to be the Saviour of mankind!

The Gospel narrator quotes the word of God to the Prophet Isaiah as being fulfilled in Christ: "Here is My Servant, whom I uphold, My chosen One in whom I delight; I will put My Spirit on Him" (Isa. 42:1).

Christ came to be a Servant. He came to give His life for us. In the Gospels, we never find Him pursuing His own interests. His whole life and ministry was for others.

This title of Christ is one of the most eloquent expressions of the love of God. That He would divest Himself of His infinite splendor and take on Himself our limitations, our poverty, our suffering—to be a Servant—loftily testifies to the unspeakable and incalculable love of God for man. The Apostle Paul, contemplating the marvel and majesty of this sublime truth, expressed it in immortal words:

> [He] made Himself nothing,
> taking the very nature of a Servant,
> being made in human likeness.
> And being found in appearance as a man,
> He humbled Himself

and became obedient to death—
even death on a cross! (Phil. 2:7-8)

On the occasion when some of the disciples displayed ambition for position and promotion, our Lord Himself set down the rules of what Christian living is all about: "Whoever wants to be great among you must be your servant—just as the Son of man did not come to be served, but to serve, and to give His life as a ransom for many" (Matt. 20:26-28).

These are hard words in a world that seems obsessed with pleasure, possessions, perquisites, and success. But servanthood becomes the terms of discipleship. Those who would qualify as saints must become servants.

The Apostle Paul could have considered himself the prima donna of the early Christian church. But how does he introduce himself in his epistles to the churches? To the church in the capital of the Roman Empire he writes: "Paul, a servant of Christ Jesus" (Rom. 1:1). Peter did not assume any of the veneration and pomp ascribed to him by others, but also addresses himself as "Simon Peter, a servant . . . of Jesus Christ" (2 Peter 1:1). Jude, the brother of Christ, claims no special position but opens his epistle with "Jude, a servant of Jesus Christ" (Jude 1). And the disciple who was closest to Jesus, in the closing book of the Bible states that the great vision was made known "to His servant John" (Rev. 1:1). We are all called to be servants of our Lord. But it is a servanthood of the highest privilege and profession.

Colonel James Irwin, a former astronaut who became a lunar pedestrian, shares that while walking on the moon he realized that when he would return to earth many would consider him an international celebrity. Realizing his role as a Christian, He records: "As I was returning to earth, I realized that I was a servant, not a celebrity. I am here as God's servant on Planet Earth to share what I have experienced that others might know the glory of God."

If Christ, Lord of the universe, became a Servant for us, can we do any less for Him?

Dear Lord, my model for living, help me by Your grace, not to seek to be served, but to serve.

Portrait Thirty-Eight
CHRIST

We have found the Messiah, (that is, the Christ) (John 1:41).

In our listing of titles in the Old Testament we included the *Messiah. Christ* is the Greek equivalent of the Hebrew *Messiah.* It means the "Anointed One." Our chapter on the Old Testament title related to it in prophecy whereas our title in the New Testament relates to it in fulfillment.

This title was especially associated with prophecy. Throughout the Old Testament there were many prophetical utterances concerning the Messiah or God's Anointed One who should come. He is the Seed of the Woman in Genesis, the Star and Scepter in Numbers, the Redeemer in Job, the Rose of Sharon in the Song of Solomon, the Servant of God in Isaiah, the Lord of Righteousness in Jeremiah, the Messiah in Daniel, the Desire of All Nations in Haggai, the King in Zechariah, and the Messenger of the Covenant in Malachi.

Not only was the Messiah prophesied to come, but there were particularized many aspects about His coming. The city where He would be born, the heralding work of John the Baptist, His sojourn in Egypt, His type of ministry, His betrayal, death, and resurrection were all graphically foretold in many minute details that only Christ could fulfill.

The story is told of Penelope being annoyed by suitors after Ulysses had been gone 10 years. Thinking him to be dead she at last promised to marry the one who should shoot an arrow through twelve rings with the bow Ulysses had used. In the

meantime, Ulysses arrived disguised as a beggar and came to the place of trial. One by one the suitors stepped forth but found they were unable to bend the bow. Then spoke Ulysses, "Beggar as I am, I was once a soldier and there is still some strength in these old limbs of mine, let me try." The suitors jeered him, but Penelope consented for him to try. With ease he bent the bow, adjusted the cord to its notch and sped the arrow unerring through the rings. It was Ulysses! Penelope threw herself into his arms.

It was not enough for Christ to claim to be the Messiah. He proved by His credentials in fulfilling the divine prophecies that He was indeed the Messiah. He is irrefutably the unerring fulfillment of the messianic prophecies. Not one of them fails to fit His life and ministry. Every Old Testament reference to the Messiah validates Christ's breathtaking claim, "I am He" (see John 4:26).

The Messiah was the One greatly longed for among the Jews. At the time Jesus was born, there was an air of expectancy because of the teaching by the prophets that the Messiah would come. Thus the statement of the Samaritan woman, "I know that Messiah" (called Christ) "is coming" (v. 25). Thus the elated announcement by Andrew to his brother Peter, "We have found the Messiah" (1:41). The Sanhedrin demanded of Him, "If You are the Christ . . . tell us" (Luke 22:67).

This story is told of a woman who lived alone in the hills of the South and had all along her living room walls pictures of Robert E. Lee. One night in a snowstorm two men came and stopped at her house for temporary shelter. When leaving, one of the men, very distinguished in appearance, gave her a little gift. The woman asked the other man the name of her distinguished and kind guest. He replied, "That, ma'am is General Robert E. Lee." Though she had his pictures she did not recognize him when he came.

The Messiah was portrayed in the Old Testament and the prophecies were known to every devout Jew. Yet most did not recognize and accept Him as the Messiah when He came. Their concept was too selfish, materialistic, and nationalistic instead of spiritual.

Christ, fulfill Your great and gracious purposes in my life.

Portrait Thirty-Nine
MAN OF SORROWS

He was despised and rejected by men, a Man of Sorrows, and familiar with suffering (Isa. 53:3).

This title and portrait of the Master is so indelibly etched in the pages of the New Testament that it immediately stands out as one of the cardinal titles of Christ. Some notable men are men of wealth, some are men of fame, some are men of pleasure, but Christ was a Man of Sorrows. He was the Prince of martyrs, the Lord of anguish, the King of suffering.

The last week of Christ's earthly life, with its record of deep sorrow, looms most prominently in the Gospels. One-third of Matthew, one-third of Mark, one-fourth of Luke, and one-half of John's Gospel is devoted to the last week of the life of Jesus. This is in striking contrast to the few pages of biography covering the death of other men of history. An example is a biography of Abraham Lincoln with only 25 out of its 5,000 pages relating the dramatic account of the assassination and death. The amount of space in the Gospels devoted to Christ's suffering and death is so disproportionate as to underscore the paramount value of that period in His life and ministry.

Deity becoming incarnate is in itself a marvel of the ages. That incarnate Deity should be so predominantly characterized by sorrow makes us aware that, as we think on this title, we are entering into the holy of holies in the sanctuary of Christ's life. We are standing before one of the most sublime and sacred truths of eternity. It is too deep for us to plumb its mystery and majesty.

The sorrows and anguish of Jesus defy description or defini-
tion. His love was wounded in betrayal and denial by those of
His most intimate circle. He was burdened with the awesome
responsibility for the redemption of the world. His soul suf-
fered imputed condemnation for man's transgressions. His
body felt the torture of the cross. He had to endure ignominy,
mockery, and the death of the cross. There was the dereliction
and loneliness of Calvary. Oh, to what fathomless depths God
descended to rescue a dying world!

Some years ago when we were having family devotions, one
of our little girls was struck by the fact that Jesus suffered so
much on Calvary. Quite unaware of the theological profundity
of her question, she asked in deep sincerity, "But if Jesus was
God, why did He have to die?" As we contemplate the unex-
ampled sorrows and sufferings of Christ, we cannot help but
cry, "Why? Why?" Isaiah answers this question for us in
immortal words:

> Surely He has borne our griefs
> and carried our sorrows;
> yet we esteemed Him stricken,
> smitten by God and afflicted.
>
> But He was wounded for our transgressions,
> He was bruised for our iniquities;
> the chastisement for our peace was upon Him,
> and by His stripes we are healed.
>
> All we like sheep have gone astray;
> we have turned every one to his own way;
> and the Lord has laid on Him
> the iniquity of us all.
> ISAIAH 53:4-6, NKJV

The nails that tore through His sacred hands and feet were
our sins. The thorns that pierced His brow and marred His
visage were our sins. The scourge that lacerated the flesh of
His back to ribbons was our sins. The wagging heads that
mocked Him and the tongues that vilified Him were our sins.

"He was wounded for our transgressions." As the Man of

Sorrows He took on Himself our burden and penalty of sin. He bore it for us. He carried our sorrow. He suffered our condemnation. He endured our agony. He died our death.

Man of Sorrows, thank You for Your sufferings on my behalf. Save me from seeking comfort in place of the cross, security in place of sacrifice.

Portrait Forty
RABBONI

She turned toward Him and cried out . . . "Rabboni"
(John 20:16).

The same love that constrained Mary Magdalene to be at the
foot of the cross, now brought her to the sepulcher on the first
day of the week. She was weeping for the loss of her beloved
Lord. A "stranger" appeared by the garden tomb and asked
why she was weeping and for whom she was looking. There
was that dramatic moment when Jesus spoke her name,
"Mary." She recognized His voice and joyously cried out,
"Rabboni." And to Mary belongs the honor of being the first
person to see the risen Christ.

It is memorable that it was a woman who had this high
privilege. She who had been forgiven much, became one of
our Lord's most devoted followers and is singularly honored in
the climax of the Gospels.

The title "Rabboni," is a term that carries the utmost respect,
reverence, and love. It is a more emphatic and honored term
than the more simple "rabbi."

Mary at the tomb made the grandest discovery of all—the
risen Christ. The account reads she went to proclaim the
glorious news, "I have seen the Lord!" At the tomb was the
last time Christ was called by the term "Rabboni" or its near
equivalents—"master," "teacher," "rabbi." From this momen-
tous day, He would be the risen, triumphant, reigning Lord.

It is not enough that we ascribe to Christ those titles of
respect and tradition. We too must know Him as our risen

Lord. We too have a mandate and a mission to proclaim the Good News from personal experience, "I have seen the Lord." Only a vibrant encounter with the resurrected Christ and a recognition of His mighty power leads us to know Him as He truly is and to share His message with others. In that discovery is our destiny.

Risen Christ, keep me ever under the spell of Your mighty resurrection.

Our Lord's
ABIDING
MINISTRY

Portrait Forty-One
SHILOH

The scepter shall not depart from Judah, nor a lawgiver from between his feet, until Shiloh comes; and to Him shall be the obedience of the people (Gen. 49:10, NKJV).

This title comes to us from the poem and prophecy of the aged patriarch Jacob who, on his deathbed, speaks to each of his sons. As we read Jacob's pronouncements of blessings, we find scathing rebuke where there had been moral failure. Instability, unbridled lust, and cruelty had forfeited the privileges of birthright. As we read on, we find that the special blessings are reserved for the tribes of Judah and Joseph.

In the blessing pronounced on the tribe of Judah, we discover another piece of the mosaic of messianic prophecy. Now the very tribe is revealed out of which will come the Messiah.

This prophecy gives us the cryptic name *Shiloh*. It comes from a verb signifying *to rest*. It is prophetical of the rest and peace which Jesus gives to His followers. In this war-haunted world there are millions to whom this title should give reassurance. He is able to give an inward peace and equilibrium amidst the disquietude and turmoil of the outward world.

In Paris, I observed on the Rue de la Paix, the Street of Peace, a towering and ornamented monument of Napoleon. It seemed incongruous that this man of war and bloodshed should be so prominently positioned over the Street of Peace. Jesus Christ towers over the centuries of strife and bloodshed as the only One who can give true rest and peace.

There is a place in Tennessee with this beautiful name of Shiloh, meaning *rest*. However, it is known only as a place of

bloodshed. Our encyclopedias, dictionaries, and history books define it as a battlefield of the Civil War where 25,000 men were mortally wounded. The events are far removed from the meaning of its name.

In his book, *Peace of Mind*, Joshua Liebman tells of an experience he had as a young boy. He made a list of what he thought to be the best things in life and took them to a wise mentor. When he showed his list, he expected to be praised for his discernment.

The list included such treasures as health, beauty, riches, talents, friends, faith. The wise old man reviewed the list and then reached for a pencil and drew a line through all the things Joshua had written down. Then the sage said, "Young man, you may have all of these—health, beauty, riches, talents, friends, faith—but they will turn out to be enemies instead of friends unless you have the one thing you missed." Then he wrote on the paper: "The gift of an untroubled mind."

That is the gift the One who is Shiloh wants to give to us. Amidst the turmoil, tragedies, and terrors of our world, He will give us the gift of an untroubled mind.

Jesus Christ is true to the meaning of each of His great titles. They are all in perfect keeping with His character and mission. He is the only One who will bring rest to His people. Just as He stilled the storm-tossed and troubled waters of the Sea of Galilee, so He will still the squalls and storms that would disrupt our lives and our peace.

We need to hear again His gracious promise, "Come to Me, all you who are weary and burdened, and I will give you rest" (Matt. 11:28).

Source of peace, give me Your great gift of inward rest, of an untroubled mind.

Portrait Forty-Two
STAR

A star will come out of Jacob (Num. 24:17).

The story of Balaam is one of the most puzzling portions in the account of Old Testament history (Num. 22:5–24:25). Balaam was a man of contradictions on a seesaw of good and evil. He feared God, but he worshiped gold. He was a prophet of the Most High, but he was a sorcerer. He pronounced blessings on Israel, but then counseled how it could be destroyed. He is a pitiful example of the solemn warning of Christ that we cannot serve two masters; we cannot serve God and mammon.

Balak, king of Moab, as neighboring cities had fallen, became worried that Israel would make a similar conquest of his city. He sent for the sorcerer Balaam, asking him to curse Israel. In the end, Balaam advised the way to destroy Israel was to entice them with Moabite and Midianite women. Calamity did result with Balaam slain and 24,000 Israelites perishing (Num. 25:9; 31:8, 16). Balaam's name was to become a byword for greed (Jude 11) and treachery (Rev. 2:14).

But, before Balaam succumbed to greed and treachery, he pronounced four oracles or prophecies. These prophecies were remarkable predictions of the influential place Israel would have in history and God's blessing on them as a nation. In his fourth and final prophecy, Balaam had an extraordinary vision: "I see Him, but not now; I behold Him, but not near. A Star will come out of Jacob" (Num. 24:17). There would be One who would rule Israel in the future, not now, nor is He nigh.

The star in that day was a symbol of a brilliant leader. Able and devout commentators have seen this text as a prophecy of the Messiah, of Christ who would come from the lineage of Jacob, whose birth would be heralded by a star, and who would be the ultimate Ruler of His people.

Man knows of nothing in the physical world that can compare to the glory and grandeur of the stars. Their colossal size, incomputable energy, and brilliance as lamps throughout the fathomless depths of intergalactic space, are mind-boggling to consider. Their unerring precision enabled man for centuries to chart his way through the pathless seas and over long distances by these sure signposts in the skies. We even reckon our time within milliseconds by these faithful clocks of the heavens.

To the Christian, Christ is our Star, His power is without measure. His radiance penetrates the deepest darkness of man's soul and needs. He is the unerring Guide who will lead us safely through our journey of life. With the psalmist we would say, "My times are in Your hands" (31:15). In that ultimate world and universe of the spirit, the grandeur and glory of Jesus Christ is without comparison.

With Horatius Bonar, Christians join in song in devotional expression of the truth of this title of our Lord:

> I heard the voice of Jesus say;
> I am this dark world's light;
> Look unto Me, thy morn shall rise,
> And all thy day be bright.
> I looked to Jesus, and I found
> In Him my star, my sun;
> And in that light of life I'll walk
> Till traveling days are done.

Christ, be the Star of my life that I may know Your radiance, Your power, Your guidance.

Portrait Forty-Three
SCEPTER

A Scepter will rise out of Israel (Num. 24:17).

"A Star will come out of Jacob; a Scepter will rise out of Israel" was the prophecy of Balaam that spoke of God's special blessings for Israel. We have seen that a star in that day symbolized a brilliant leader. A scepter was a symbol of authority.

In that time of history, a king's authority and power were symbolized by two objects, possessed only by the king—his crown and his scepter. His scepter was a highly ornamented rod or staff, held on ceremonial occasions as a symbol of sovereignty.

An interesting episode is given in the story of Esther who needed to come into the presence of the king to save her people from the plot to destroy them. But there was a law that any man or woman who approached the king in the inner court without being summoned would be put to death. The record states, "The only exception to this is for the king to extend the gold scepter to him and spare his life" (Es. 4:11). There is that dramatic moment, after three days of fasting, when Esther risked her life and approached the king who was sitting on his royal throne. The familiar story records that the king "held out to her the gold scepter that was in his hand. So Esther approached and touched the tip of the scepter" (5:2). The result was that Esther saved her nation.

Christ declared, "All authority in heaven and on earth has been given to Me" (Matt. 28:18). The scepter of ultimate au-

thority is not only in His hands—He is the Scepter; He is divine power and authority. Mankind in his sinful condition could not approach a holy and righteous God. Christ the Scepter, has reached out to us and by His touch on our lives, transforms us and enables us to come into the very presence of God the Father. By His grace, instead of incurring the wrath of God, we may know His love and blessing.

With the hymn writers, Bridges and Thring, we would raise our voices to "Crown Him with Many Crowns":

> Crown Him the Lord of peace,
> Whose power a scepter sways
> From pole to pole, that wars may cease
> And all be prayer and praise;
> His reign shall know no end,
> And round His pierced feet
> Fair flowers of paradise extend
> Their fragrance ever sweet.

Lord, rule supremely over all my desires, motives, ambitions, actions, and aspirations.

Portrait Forty-Four
REDEEMER

I know that my Redeemer lives, and that in the end He will stand upon the earth (Job 19:25).

From Job, the Shakespeare of the Old Testament, we have this textual jewel. It shines all the brighter because of its night-enshrouded setting. Job had experienced in quick succession the loss of his possessions, children, and health, the reproof of his wife, and the suspicion of his friends. He could well have become the world's greatest pessimist. Instead we see him giving the classic example of positive thinking in a negative situation—"I know that my Redeemer lives."

What did this word *redeemer* mean when uttered by Job? The Hebrew word *goel* represented the kinsman whose duty it was to recover a captured or enslaved relative.

We were captives of sin and Satan. Jesus delivered us from this enslavement and made us free.

This word in its original meaning also meant that the kinsman would recover sold or forfeited inheritance. He was the chief defender not only of the person but also of the possessions of the one over whom he was a protector. This was a part of the Mosaic Code.

The loss of paradise was for man a tragedy. Sin made him forfeit his spiritual inheritance; it disfranchised him of his heavenly citizenship; it robbed him of his nobility; it left him a miserable pauper. But Christ as our Redeemer has recovered our lost estate for us if we will accept His act of redemption. He is the Elder Brother, our great Kinsman, who undertook to win

back for us that which we had lost.

This text is animated with three vital concepts of our faith—immortality, resurrection, and the return of Jesus Christ.

These words were a lofty climax to the speeches of Job. They proclaim the message that is most needed in the world today—Christ is vibrantly alive and will someday make His reentry into our troubled and tortured world. In the grand denouement of Creation, "He will stand upon the earth."

Job, through his telescope of faith, perceived and flung out this towering truth of the Old Testament. In one of the rare references before Christ to immortality, he exclaimed, "And after my sin has been destroyed, yet in my flesh I will see God" (v. 26). This statement is a landmark of faith and truth in the Old Testament. Mankind had to await the resurrection of our Lord and the luminous insights of the New Testament before immortality came into clear focus for the believer.

William Jennings Bryan in his lecture, "Prince of Peace," expressed eloquently and cogently this belief:

> If the Father deigns to touch with divine power, the cold and pulseless heart of the buried acorn and makes it burst forth from its prison walls, will He leave neglected in the earth the soul of a man made in the image of his Creator? If He stoops to give to the rose bush whose withered blossoms float upon the autumn breeze the sweet assurance of another spring, will He refuse the words of hope to the sons of men when the frost of winter comes? If matter, mute and inanimate, though changed by the forces of nature into a multitude of forms can never die, will the imperial spirit of man suffer annihilation when it has paid a brief visit like a royal guest to this tenement of clay?

To our questions and questing for life after death, there comes resounding down the millennia, this inspired affirmation, which shines all the more radiant in the light of the resurrection of our Lord.

My Kinsman, thank You for redeeming my soul from the clutches of Satan and for paradise gained through Your grace.

Portrait Forty-Five
ROSE OF SHARON

I am a Rose of Sharon (Song 2:1).

From this lyrical love song of the Bible, we have these companion titles that have been ascribed to Christ—*Rose of Sharon* and *Lily of the Valley.*

These two titles are set in the context of an exuberant and eloquent expression of love, which many have interpreted as an allegory of the relationship between the Lord and the Christian. It is a nuptial anthem with a dialogue of love in the most intimate and endearing language. The beloved yearns for the fragrance of her lover's presence and even his very name makes her exude the ecstasy of love: "Pleasing is the fragrance of your perfumes; your name is like perfume poured out" (1:3).

These beautiful titles for our Lord have become part of our devotional language. Among our hymns are the well-loved, "Jesus, Rose of Sharon" and "He's the Lily of the Valley." Our Lord is as the exquisite flower that thrives in the cool countryside or in the quiet field. We discover His beauty when we come apart from the hustle and bustle of life and enter into the solitary and sweet communion with the Lover of our soul. Then, with the lyricist of this book, we will joyfully witness: "He has taken me to the banquet hall, and his banner over me is love" (2:4).

The rose of Sharon was probably the common and abundant meadow-saffron, crocus, or narcissus. It adorned the countryside with its delicate beauty and perfumed the air with its

P O R T R A I T F O R T Y - F I V E

sweet fragrance. As a term associated with our Lord, it speaks to us of the beauty and fragrance He brings to those who know and love Him.

In a valley of Rumania, roses are grown for the Vienna market in great profusion and with much distillation of fragrance. We are told that if you were to visit that valley at the time of the rose crop, wherever you would go the rest of the day, the fragrance you would carry with you would betray where you had been.

There is a beautiful parable given us by the Persian poet and moralist, Saadi. The poet was given a bit of ordinary clay. The clay was so redolent with sweet perfume that its fragrance filled all the room.

"What are you, musk or ambergris?" he questioned.

"I am neither," it answered, "I am just a bit of common clay."

"From where then do you have this rare perfume?" the poet asked.

"I have companied all the summer with the rose," it replied.

We are just bits of the common clay of humanity. But if we company with the One who is the Rose of Sharon and the Lily of the Valley, something of the fragrance of His life will pass into ours. Then we will be a freshening and a sweetening influence to the world around us.

Rose of Sharon, bloom and blossom and infuse Your fragrance in my life.

Portrait Forty-Six
LILY OF THE VALLEY

I am the . . . Lily of the Valley (Song 2:1, TLB).

Some say that the lily was the scarlet martagon or the white amaryllis. These flowers, as titles associated with our Lord, are suggestive of His character and mission in several ways.

The white amaryllis is only three inches from the ground and has a drooping head. It is emblematic of humility and the One who said, "Learn from Me, for I am gentle and humble in heart" (Matt. 11:29).

Like these lowly flowers of the field ready to be trodden underfoot of man and crushed, Christ humbled Himself and exposed Himself to the brutality of men.

This title also speaks of the beauty of Christ. Jesus spoke of the lilies of the field as adorned with a beauty to which all the glory of Solomon could not be compared. The wild flowers of Israel were very beautiful. The life of Jesus Christ was beautiful in purity, in holiness, in love, in holy power, in radiant joy and goodness.

The brightness of His beauty will never blemish, the luster of His love will never lessen. And, wonder of wonders, our common lives may reflect His winsomeness and the beauty of His holiness. The late Albert Orsborn penned a chorus that expresses the heart's longing to partake of that beauty:

> Let the beauty of Jesus be seen in me,
> All His wonderful passion and purity;

Oh, Thou Spirit divine, all my nature refine,
Till the beauty of Jesus be seen in me.

This title is further suggestive of the fragrance that was diffused from His life. The white amaryllis was especially sweet-scented. We may partake and pass on the spiritual fragrance of the life of Christ.

Jesus, Lily of the Valley, bloom in all Your beauty in the garden of my heart.

Portrait Forty-Seven
WONDERFUL COUNSELOR

And He will be called Wonderful Counselor (Isa. 9:6).

The traditional *King James Version* of the Bible separates the above as two titles, but more recent Bible scholars regard the comma between them as an error. More recent translations tend to render this title as "Wonderful Counselor."

Isaiah has given us, in this magnificent verse, a constellation of titles. Its lofty appellations declare the superlative qualities of the messianic King. The first title emphasizes His wisdom.

We cannot deny our need for wise counsel and our reliance on divine guidance. Life is often perplexing, bewildering, complex, problematic, disconcerting. We have an inescapable need for the Divine Counselor.

A counselor is one who advises, instructs, and guides in directing the judgment and conduct of another. He is involved in the intimacies of life, directing it through its crises and critical periods. Counselors become custodians of the crises of life. It is a staggering responsibility. It is a sacred responsibility. What are the essential qualifications of a counselor?

A counselor needs to be *close*, accessible. Jesus Christ is as close as the whisper of a prayer. He is always available, never away or too busy. He will ever attend to our prayer and help us in our need.

The *confidential* aspect of counseling is inherent in Christ's counseling to His followers. To Him, we can take the most intimate matters of the heart.

He is *compassionate*—tender, loving, concerned for us. To Him we are not a case, but a child; not a problem person, but a person with a problem and potential.

He is *cognizant* of us and our needs and He knows what is best for us. A counselor must have a good knowledge of the person to be counseled. Some counselors fail because they never achieve a thorough understanding of the person. It is difficult indeed to penetrate the subtleties of human emotions, motivation, and the makeup of our subconscious which dictates so much of our conscious life. The inspired chronicler writes: "He knew all men. He did not need a man's testimony about man, for He knew what was in a man" (John 2:24-25). Jesus Christ knows and understands us better than we know ourselves. He is the specialist of the human heart.

As a Counselor He is *capable*. He has all the resources of power and help to put at our disposal. He is omniscient. He is wisdom incarnate. He is inerrant in His counsel to us. He will always guide our steps aright.

Another essential qualification of a counselor is that he be able to *communicate* and enable the person to discover the resources needed for his situation. We can communicate to Christ in prayer. How does He communicate to us? Is not prayer a dialogue rather than a monologue? If we exercise the discipline of silence and stillness, does not Christ speak to us through inward promptings, the engenderings of convictions, the sensitizing of conscience? Does He not also speak to us through the gentle stirrings of His Spirit? And has He not left for us His *counselor's manual* for the human heart in the communication of His Word?

We may with confidence bring to Him the hurts, the failures, the deep needs and aspirations of our lives. For Christ is the Counselor par excellence. He is the Wonderful Counselor.

> *Wonderful Counselor, I would yield my foolishness to Your wisdom, my perplexity to Your guidance, my darkness to Your light, my future to Your prescience, my life to Your way and will.*

Portrait Forty-Eight
THE PRINCE OF PEACE

And He will be called . . . Prince of Peace (Isa. 9:6).

Peace often seems to be the most sought for and, at the same time, the most elusive treasure. The great cry of the world is for peace. The diligent and devoted effort of so many world leaders and diplomats is on behalf of peace. Yet history seems to mock their effort and confirm the futility of man's search for peace. A famous French historian estimated that there had been 3,130 years of war in contrast to 227 years of peace from the fifteenth century before Christ to his own day. The world had seen 13 years of war for every year of peace.

Today nuclear destruction threatens civilization as cities and nations stand only by sufferance and often seem headed on a collision course with annihilation. Every new generation is born under the ominous cloud that threatens to unleash a nuclear holocaust. In the next deadly game of war, the score will be kept in units of a million corpses.

This is not only the era of the split atom but of the split personality as well. Man is beset by neuroses and psychoses that undermine his peace from within. The fears of man are so many and varied that psychologists have charted them all the way from *a* to *z*: acrophobia, fear of heights, to zoophobia, fear of animals. People cannot sleep. Americans are the champion insomniacs, consuming billions of pills a year. The classic words of Henry Thoreau seem more apposite to our age than to his time, "The mass of men lead lives of quiet desperation."

The heart of the problem is the problem of the heart. Peace is not so much an external climate as it is an inward experience. It gives inner equilibrium to the life amidst the disquietude without. As the Prince of Peace, Jesus imparts His peace that applies to three primary relationships.

First, He enables us to have peace *with God* by His work of reconciliation. Sin separated and estranged man from God. The cross of Calvary was a great bridge across the impassable chasm of sin. It led the way from man's fallen condition back to his holy Creator. Augustine wrote:

> Thou has made us for Thyself, and the heart of man is restless until it finds its rest in Thee.

Second, Jesus enables us to have peace *within ourselves*. He resolves the inner conflicts, cross purposes, and tensions which act as bandits robbing us of serenity. He quells the civil war within the heart, between the carnal and the spiritual nature, by the power and work of the Holy Spirit.

When we are at peace with God and with ourselves, then we will be at peace in the third area of relationship—with others. Having truly discovered the Fatherhood of God we will learn to practice the brotherhood of man. When the vertical relationship is right then the horizontal relationship will take on its proper perspective.

The four exalted titles of this text speak to us of four divine attributes of our Lord. *Wonderful Counselor* speaks of His omniscience. *Mighty God* declares His divine attribute of omnipotence. *Everlasting Father* or "Father of Eternity" indicates there is no point in time or space where He is not present, expressing His attribute of omnipresence. And *Prince of Peace* relates to our positive well-being, and His attribute of omnificence—unlimited in His creative bounty on our behalf.

The Prophet Isaiah elsewhere gives us the secret of peace: "You will keep in perfect peace him whose mind is steadfast because he trusts in You" (26:3). When our hearts and minds are centered on Christ, we will know His serenity amid storms.

Prince of Peace, so attune my heart that there will be no disharmony of desire, no discord of selfishness.

Portrait Forty-Nine
BANNER FOR THE PEOPLES

In that day the Root of Jesse will stand as a Banner for the peoples (Isa. 11:10).

A banner in that day could be a symbol, a flag, or a flagstaff. It would often be lifted up on a hill as a signal for gathering the troops or a rallying point for the people. Isaiah here prophesies that Christ would be as a banner, or a rallying point for the people.

The Caesars carried the Roman banner throughout the conquered world, but all their glory turned to ashes. Hitler raised his swastika on top of Mount Olympus, the mythical home of the ancient Greek gods. But his Third Reich crumbled in less than a generation and left a legacy of shame and death.

A Carpenter raised a banner of a gallows, flung up on a Judean hill, and around it has rallied an innumerable multitude. On Calvary, the century-old prophecy of Isaiah was fulfilled: "In that day the Root of Jesse will stand as a Banner for the peoples: the nations will rally to Him, and His place of rest will be glorious" (Isa. 11:10).

Napoleon, a man of giant intellect who, as a mighty son of Mars, strode through the world like a colossus, compared Christ with himself in rallying men to devotion:

> I have inspired multitudes with such devotion that they would have died for me. But to do this it was necessary that I should be visibly present, with the electric influences of my looks, of my words, of my voice. Christ alone

has succeeded in so raising the mind of man toward the unseen that it becomes insensible to the barriers of time and space. Across a chasm of 1,800 years, Jesus Christ makes a demand which is, above all others, difficult to satisfy. . . . He asks for the human heart. He demands it unconditionally, and forthwith His demand is granted. In defiance of time and space, the soul of man with all its powers becomes an annexation to the empire of Christ. All who sincerely believe in Him experience that remarkable supernatural love toward Him. This phenomenon is unaccountable. . . . This it is which proves to me quite conclusively the divinity of Jesus Christ.

Lord, with Your followers of all nations, I would rally around the blood-stained banner of the cross.

Portrait Fifty
LEADER AND COMMANDER

See, I have made Him a . . . Leader and Commander of the peoples (Isa. 55:4).

Dr. Scott Peck, author of the bestseller, *The Road Less Traveled*, had just presented an insightful address to the U.S. Church Leaders Conference in New York. During the discussion period, I asked this renowned psychiatrist, "What influenced you to your commitment to Jesus Christ?" Dr. Peck responded by sharing there were a number of influences over a period of time but the turning point came when he went to the Gospels to do his research on Christ for his book. He stated: "I was absolutely thunderstruck by the Man I found in the Gospels. I encountered this extraordinary, real Human Being. If the Gospels had tried to create a myth, it would have been quite different. The Jesus of the Gospels is one of the church's best kept secrets. I was beginning to fall in love with Jesus." Such was the dynamic impact of Jesus Christ 2,000 years after His death, on a highly urbane, intellectual doctor of our day.

We tend to read the Gospels glibly and lose sight of the dramatic impact of Jesus Christ on people of His day. Multitudes were magnetized to Him, learned religious leaders and doctors were astonished by Him, children were drawn to Him, rough and uncouth fishermen left their boats to follow Him, and young men were willing to lay down their lives for Him. Talk about charisma! Leadership! The impact of Jesus Christ on the people of His day and on His world 2,000 years later is nothing short of sensational!

He was, in the ancient text of Isaiah, "A Leader and Commander of the peoples." There are some commanders who do not know how to lead and there are some leaders who do not know how to command. But Christ consummately combined the arts of leadership and command.

To Peter He said, "Follow Me," and the big fisherman followed Him to paths of immortality. To Matthew He said, "Follow Me," and he went on to write the greatest story ever told. To Paul He said, "Follow Me," and Paul followed Him throughout the empire and to a Roman dungeon. To William Booth He said, "Follow Me," and he was led to minister to the poor in His name throughout the world. To Albert Schweitzer He said, "Follow Me," and he went to the African forest. To Father Damien He said, "Follow Me," and he followed Him to the isle of lepers.

As centuries ago by the pebbled shore and blue waters of the Syrian Sea, so He walks our way and again gives His great and gracious invitation, "Follow Me."

With John Henry Newman, we would pray:

Lead kindly Light, amid the encircling gloom,
 Lead Thou me on!
The night is dark, and I am far from home;
 Lead Thou me on!
Keep Thou my feet I do not ask to see
The distant scene: one step enough for me.

Precious Lord, take my hand and lead me in paths of righteousness and service.

Portrait Fifty-One
LORD OUR RIGHTEOUSNESS

This is the name by which He will be called: The Lord Our Righteousness (Jer. 23:6).

"Then they will go away to eternal punishment, but the righteous to eternal life" are the final words of the almost 100 verses that comprise the Olivet Discourse of Christ that deals with the end of the age (Matt. 24:3–25:46). Our Lord makes it quite clear that only the righteous will go to heaven and have eternal life.

But that poses a problem. Isaiah confesses for all of us: "All our righteous acts are like filthy rags" (64:6). And Paul reinforces this truth: "There is no one righteous, not even one" (Rom. 3:10). What then is the answer to our dilemma?

With Paul we also may say: "That I may gain Christ and be found in Him, not having a righteousness of my own that comes from the Law, but that which is through faith in Christ—the righteousness that comes from God and is by faith" (Phil. 3:8-9). By the merit of the vicarious sacrifice of Christ for our sin, His righteousness is imputed to us.

A Greek legend tells of Theseus who volunteered to be locked in the vast labyrinth beneath the city of Minos. Theseus faced two dangers underground: the fierce minotaur who devoured all those he trapped within, and the maze itself, an unending network of intricate tunnels. Just before he entered the tunnels, the beautiful princess Ariadne, secretly slipped him a spool of thread. By unraveling the thread as he pursued the minotaur, Theseus laid a trail by which he could find his

way back. Without the thread, he would have wandered hope-
lessly through those winding passages.

As we seek to overcome Satan and his destructive power,
and to make our way through earth's maze to that eternal city,
the righteousness of Christ alone will enable us to attain that
ultimate goal of our life.

Charles Wesley has translated Zinzendorf's hymn that gives
expression to this truth:

> Jesus, Thy blood and righteousness
> My beauty are, my glorious dress;
> 'Midst flaming worlds, in these arrayed,
> With joy shall I lift up my head.

Lord, help me to hunger and thirst after righteousness.

Portrait Fifty-Two
DESIRE OF ALL NATIONS

And they shall come to the Desire of all nations
(Hag. 2:7, NKJV).

Patriotism became fashionable again on the memorable July 4th, 1986 weekend when our nation held its biggest-ever birthday party in celebration of the Statue of Liberty Centennial. It was an extravaganza nonpareil with the flotilla of stately ships, spectacular fireworks, opulence of music and choreography, and the Master of Ceremonies none other than the President of the United States. In that dramatic moment of the unveiling of the "mother of exiles," symbol of America's liberty and the dreams of millions who came to these shores, Americans swallowed capsule-sized lumps in their throats with pride for our heritage of freedom. Many again prayed, "God bless America," and "May her land be bright with freedom's holy light" as we coveted the best for the country we love.

The Prophet Haggai, writing just after the Exile of the Jews, was calling his nation to return to greatness. Israel had just come through the 70 years of Exile and humiliation. God spoke through the prophet to impress on them their spiritual barrenness: "You have planted much, but have harvested little. You eat, but never have enough. You drink, but never have your fill. You put on clothes, but are not warm. You earn wages, only to put them in a purse with holes in it" (1:6). It is a message for a nation caught with seeking its own selfish interests. The prophet charged them with being so busy with their own affairs that they had no time for the things of God

129

(vv. 4, 9). They had looked after their own comforts which now became their condemnation.

But now Cyrus, the Persian conqueror, issued a decree and the Babylonian Captivity came to an end. The Jews could return to their homeland and restore their place of worship. There would be strong opposition from the neighboring peoples and many of the Israelites had become comfortable in the land of their Captivity. God called the Prophet Haggai to challenge them to return and receive His blessing (2:19). In the midst of this call to return to their spiritual heritage, he gave this unique title that has been ascribed to our Lord, as he prophesies, "The Desire of all nations will come." It is the Hebrew word *chemdah* which means "delight, desire, goodly, pleasant, precious." It speaks of the good that comes to a nation when Christ is known.

Jesus Christ is truly the highest good and the source of true greatness for a nation. He is still the "Desire of all nations." He alone can give that treasured blessing that all nations yearn and seek, promised in our text as the sequel to His coming: "I will grant peace" (v. 9).

We are all exiles, serving under the oppressive enemy of our souls, until He comes with His liberty and life abundant. Four times in the two chapters of Haggai we read this characteristic phrase "Give careful thought" (1:5; 2:15, 18 [twice]). Let all peoples and all nations consider carefully and welcome the One who comes with blessing and peace. With Charles Wesley, we would sing:

> Come, Thou long-expected Jesus,
> Born to set Thy people free;
> From our fears and sins release us,
> Let us find our rest in Thee.

> All Thy people's consolation,
> Hope of all the earth Thou art;
> Dear desire of every nation,
> Joy of every longing heart.

Desire of all nations, may the rulers and peoples of the world welcome You as Lord and as the One who brings peace.

Portrait Fifty-Three
KING

Rejoice greatly, O daughter of Zion! Shout, Daughter of Jeru-
salem! See, your King comes to you, righteous and having salva-
tion, gentle and riding on a donkey, on a colt, the foal of a
donkey (Zech. 9:9).

This prophecy is inseparably linked with the Triumphal Entry.
The Gospel writer states that the Triumphal Entry was in
fulfillment of this very prophecy (Matt. 21:4-5).

Zechariah enjoined the people to shout, for the King's com-
ing would be an epochal event that would merit their most
enthusiastic and exuberant response. In our text and its con-
text, some salient features of His kingdom are given.

He would usher in a *kingdom of joy*. "Rejoice greatly" was the
injunction to the people. He is the King who would announce,
"I am come that they may have life, and have it to the full"
(John 10:10).

His would also be a kingdom of justice. So many of earth's
kingdoms are ruled by injustice marked by graft, crime, dis-
honesty, expediency, inequities. But Christ's kingdom will be
characterized by justice. It is assured by His character and
power—"He is just." He is the King of justice.

"And having salvation" speaks of the deliverance He will
bring His people. He will make His people free. Sin has often
been analogized to a pit. The pits of that day were miry at the
bottom. The only opening was at the top through which the
prisoner was thrown into the pit. Escape was impossible. But
Christ gives hope. He came to bring salvation from the deep
and inescapable pit of sin—"because of the blood of My cove-
nant with you, I will free your prisoners from the waterless

131

pit" (Zech. 9:11).

Our text also speaks of Him as a "lowly" King. He was not dependent on the props of earthly monarchs. He would not come with the pageantry and pomp of earth's transient kings. He would not mount a war horse, but at His procession would ride on an animal that was the symbol of quietness. His coming would be accompanied by palm branches rather than spears. Not the shouts of soldiers but the songs of children and the lilting "hosannas" would be the music of His coming.

His would also be a kingdom of peace—"He will proclaim peace" (v. 10). Some kings have been noted for their great battles and victories, or defeats. But others have been more renowned for their reigns of peace. Man through history has not been able to learn the lesson of peace. He is inclined to war which is collective madness. But Christ is the King of peace.

Finally, the prophet declares the universality of His kingdom. "His rule will extend from sea even to sea" (v. 10). Not only will it be without geographical boundaries, but also without time or race barriers. All people of all places of all times who have acknowledged His reign over life shall be citizens of His great kingdom. He is the King of the universe.

With Ernest Shurtleff, we would pray:

Lead on, O King eternal,
 We follow not with fears,
For gladness breaks like morning
 Where'er Thy face appears.
Thy cross is lifted o'er us,
 We journey in its light;
The crown awaits the conquest:
 Lead on, O God of might.

Mighty King of the universe, rule every motive, thought, and deed of my life. May my fidelity and service help to usher in Your kingdom of peace.

MESSENGER OF THE COVENANT

> *"See . . . the Lord you are seeking will come to His temple;*
> *the Messenger of the covenant, whom you desire, will come,"*
> *says the Lord Almighty (Mal. 3:1).*

There is an inspiring and progressive history of the covenant in the Bible. There was the covenant with Noah (Gen. 9:11), when God promised the preservation of mankind and confirmed it with the token of the "rainbow in the clouds." The Abrahamic Covenant (15:18), which gave promise of the inheritance of the Jewish nation, was entered into with impressive and symbolic ceremony. Then, as Israel came of age as a people, God entered into the Mosaic Covenant (Ex. 34:10) which established His relationship with them as a nation. David's final words speak of the "everlasting covenant" (2 Sam. 23:5) God entered into with him.

There are several essential characteristics of the biblical covenant:

1. It was a solemn and sacred agreement between God and man.
2. God was the initiator. The finite cannot initiate agreement with the Infinite.
3. Man was always the beneficiary. The biblical covenants would always foretoken some great blessing to man from God.
4. The covenant related to collective bodies. It was not merely with the individual but with his family and posterity. Noah was the representative of mankind. The covenant with Abraham was to his seed forever. Moses was

the representative of the Jewish nation. The covenant with David applied to all the lineage of the great King.

In the latter period of the Old Testament, there unfolded the concept of the New Covenant God would establish with man. Jeremiah declared God would make a "New Covenant" (Jer. 31:31). It would be a spiritual covenant and would be universal in its inclusion of all people. In the New Testament, we read, "Jesus has become the Guarantee of a better (stronger) agreement—a more excellent and more advantageous covenant" (Heb. 7:22, AMP). He is also called the "Mediator of a better covenant" (8:6, NKJV).

The word *testament* is equivalent to *covenant*. Thus the two major divisions of the Bible could rightly be called "The Old and the New Covenants."

This progressive covenant relationship has its ultimate unfolding in Jesus Christ. His redemption was the New Covenant between God and man.

Malachi prophesied that the Lord will come as the Messenger of the Covenant. He would inaugurate, announce, and implement the New Covenant with mankind. That God should enter into covenant with man is a gracious act of condescension. To contemplate its marvel staggers the mind, but it captivates the heart.

"The Lord. . . . will come." With those words the voice of prophecy was silenced for over four centuries. But man had this great promise. Thank God, He keeps His promises. The Messenger of the Covenant did come and man entered into a new and living way in relationship with God.

Christ, thank You for including me in Your covenant. Help me not only to accept its gracious benefits but also to carry out its sacred responsibilities.

Portrait Fifty-Five
SUN OF RIGHTEOUSNESS

But unto you who revere and worshipfully fear My name shall the Sun of Righteousness arise with healing in His wings and His beams, and you shall go forth and gambol like calves released from the stall and leap for joy (Mal. 4:2, AMP).

What the sun is to the earth, Christ is to the soul. Christians could aptly be called heliotropes. These are plants (such as the sunflower) that turn their faces toward the sun. Their leaves hang as in sadness when the sun is withdrawn. So the Christian is one who has turned toward the Sun of Righteousness and receives from Him life and beauty.

The sun is our source of *light*. Without its illumination, our earth would be a dark and sterile planet. Christ is our Source of spiritual light. He dispels darkness and diffuses His radiant light throughout the world and in the heart of man.

The sun is also a source of *life*. In the fall in our part of the world, there takes place a death of nature. Plants, flowers, and grass fade and die as the winter months approach. But then when springtime comes around again, a miracle takes place. There is a resurrection, a rejuvenation. Tender shoots push their way through the soil. Protoplasm is activated in every tree and begins the manufacture of new leaves, buds, and blossoms. There is an inexorable energy received from the sun which produces this new life. So is there a spiritual life that is dormant within each person. All it needs is to bask in the glow of the Sun of Righteousness to be raised to its potential of life and growth.

The sun is also a source of *beauty*. Brightness and color come from the benign rays of the sun. The sun reveals the expansive

beauty of the blue sky, the restful green of the trees and verdant meadows, the kaleidoscopic beauty of a garden. The Sun of Righteousness would adorn a life with the rich hues of His grace and make it beautiful. He will beautify the character, the personality, the relationships, and all of life.

The sun is also the *center* of our solar system, our sphere of life. At one time the universe was considered to have been geocentric—centering in the earth with everything else revolving around our planet. This was the Ptolemaic system and under that concept none of the sums would come out right. But when Copernicus discovered the heliocentric principle, the sun as the center with everything revolving around it, then science made sense. Everything added up to an intelligent sum. This is analogous to our spiritual life. When life becomes egocentric, self-centered, then it is inane and futile. It is eccentric, off center. But when we have the Sun of Righteousness as the center of our lives then they take on purpose and meaning. It comes out right.

Our text also states that the Sun of Righteousness will have "healing in His wings." Sin brought death and destruction for the soul and body, but Christ in His salvation brings *healing* for the disease of sin. His radiance will dispel the germ of sin and bring health to the soul.

The final thought of our text is that the delivered soul will be like a calf that has been confined to the stall and is suddenly freed. It gambols and cavorts and skips and leaps. So there is an *exuberance of life* imparted by the Sun of Righteousness.

The first promise made to Adam was as a feeble spark. But here, in the last book of prophecy, that spark has through the centuries become enlarged until now it has become the Sun of Righteousness that will bring illumination to the whole world.

Sun of Righteousness, illumine all my being with Your radiance so that my life will be aglow with Your light and beauty.

Portrait Fifty-Six
BRIDEGROOM

The time will come when the bridegroom shall be taken from them (Matt. 9:15).

It is an honor to receive a wedding invitation. It means you are one of the most-loved or important persons in the life of the bride and groom. The greatest honor we will ever have is God's invitation to the great marriage banquet of heaven—"Blessed are those who are invited to the wedding supper of the Lamb" (Rev. 19:9). We are each called to be a part of the great family of God that will gather at that magnificent banquet.

The penman of Patmos must have wished he could dip his pen in some iridescent ink to describe that scene before him. The marriage banquet in heaven is the grand climax of history as Christ the Bridegroom celebrates the marriage banquet with His bride—the body of believers (Rev. 19:7-21).

The concept of this nuptial relationship has its roots in the Old Testament. Hosea heard God say, "I will betroth you to Me forever" (2:19). Isaiah proclaimed, "Your Maker is your Husband" (54:5). Jeremiah echoed the Lord's appeal, "Return, faithless people . . . for I am your Husband" (3:14). In the New Testament, Jesus referred to Himself as the Bridegroom in response to the questions later posed by John the Baptist's disciples (Matt. 9:14-15).

In His Parable of the Ten Virgins, our Lord describes Himself as the Bridegroom who shall make a sudden appearance and for whose coming we need to be ready (25:1-13). And the

Apostle Paul's model for human marriage is the love of Christ for His bride, the church (Eph. 5:22-33). The marriage banquet of heaven is the grand consummation of Christ gathering with His followers in eternal fellowship and felicity.

Tennyson has given memorable expression to this title in his "St. Agnes' Eve":

> For me the heavenly Bridegroom waits,
> To make me pure of sin.
> The Sabbaths of Eternity,
> One Sabbath deep and wide—
> A light upon the shining sea—
> The Bridegroom with His bride!

Thank You, Lord, for the invitation to the grand marriage banquet. To Your "RSVP," I respond—"Yes, I'll be there!"

Portrait Fifty-Seven
FRIEND

And they say, "Here is . . . a Friend" (Matt. 11:19).

Quoting the people of His day, Jesus said they were calling Him "A Friend of tax collectors and sinners." Our Lord during His earthly ministry was known as a Friend of those who were looked down on and in need. What greater privilege than to be called a friend of Jesus.

"Every man passes his life in search for friendship," wrote Emerson. A friend is indeed the greatest treasure of life, as expressed by Helen Parker in her poem, "Discovery":

Today a man discovered gold and fame;
Another flew the stormy seas;
Another saw an unnamed world aflame;
One found the germ of a disease.
But what high fates my paths attend:
For I—today I found a friend.

Proverbs gives us the basis of friendship: "A friend loves at all times" (17:17). Love is the basis of friendship. It is love that binds and holds people together. The love of true friendship is unselfish, seeking the good of the other. Henry Ford once described "your best friend" as the one who "helps you bring out of yourself the best that is in you."

If the worth of a friend is determined by that person's love, its quality and consistency, and bringing the best out of us, our

reasoning leads us to realize the greatest Friend we have is the One who loved us with an infinite love and enables us to become the best that we can be. Jesus gave the supreme test of friendship when He said, "Greater love has no one than this, that one lay down his life for his friends" (John 15:13). Our Lord's sacrifice on Calvary is the greatest act of love ever demonstrated on our behalf. By His salvation and power He lifts life to its highest heights as He enhances, enriches, and ennobles the life we yield to Him.

During the First World War, a soldier in the trenches saw his friend wounded out in no-man's land—that ground between his trench and the trench of the enemy. The man asked his officer, "May I go, Sir, and bring him in?" The officer refused saying, "No one can live out there, and if you go I will only lose you as well." Disobeying the officer, the man went for his friend. Somehow, he managed to get him on his shoulder and stagger back to his trench, only to fall mortally wounded himself. The officer was angry, "I told you not to go. Now I have lost two good men. It was not worth it!" With his dying breath, the man said, "But it was worth it, Sir, because when I got to him he said, 'Jim, I knew you'd come.' "

Our best Friend is the One who laid down His life for us. He went out to no-man's land, and Himself was mortally wounded as He rescued us from the destruction of sin. He wants to be our Friend and has given us the condition of His friendship: "You are My friends if you do what I command" (v. 14). And His commandments are not burdens but are life and liberty to the soul.

Jesus, the greatest Lover of our soul, leans out of His immensity to say, "My friend." He waits for our response, "My Lord and God." Then will we know His transforming friendship.

Dear Lord, make me more worthy of Your friendship.

Portrait Fifty-Eight
HORN OF SALVATION

He has raised up a Horn of Salvation for us (Luke 1:69).

In Luke's account of the Advent are several songlike passages. They could be called hymns, each one flowing in style and having its own inherent message. Some churches today still incorporate words from these hymns in their liturgy.

There was the Annunciation (vv. 28-37) by the Angel Gabriel who was entrusted with the most superlative message ever sent from heaven to earth. Mary's song of praise (vv. 46-55) was expressed in the exultant words of her *Magnificat*. There is also bequeathed to us the *Benedictus* (vv. 68-79) by Zechariah, the *Nunc dimittis* (2:29-32) by Simeon, and the lovely canticle by Elizabeth (1:42). And on the night of nights the heavens rang out with the *Gloria in Excelsis* by the herald angels.

A newspaper cartoon during the Christmas season pictures a father and mother with their small children looking at a store window with its decoration and display of merchandise. In the center of the window is a large sign, "Let's make this the best Christmas ever." The father gives the punch line with, "How are they ever going to top the FIRST one?" May our recurring attention to the Christmas story each year not dull us to the wonder of that first Christmas.

The title, Horn of Salvation, comes to us from the *Benedictus* of Zechariah. It is a title with a latitude of interpretations. This metaphorical title primarily denotes strength and power. Goodspeed renders this title, "A Mighty Saviour."

Horns grew on the male animal and the bull was the strongest of the herd. It would fight off the herd's enemies by lowering its head and charging fiercely, and woe to whatever might find itself on the end of those horns. He was the protector of the herd. Christ as the Horn of Salvation, is our great Protector. He defends us against the deadly foes of the soul. We are delivered by His mighty salvation.

In Bible days, the horn was also a drinking vessel. A small horn of an animal would often be cut in such a way as to make a very useful type of drinking cup. From Christ, we receive and drink of the living water which satisfies the deepest thirsts of our lives.

The horn was also a musical instrument. The ram's horn was quite long and used as a trumpet. We are reminded that Christ replaces the discord of a life with His harmony. His presence and power can make life as a symphony with all its parts— emotions, thoughts, experiences, deeds, affections—contributing to a harmonious blending of the whole.

Finally, there were the horns of the altar. The horns were the corners and the most sacred part of the altar. There a fugitive could take hold and be protected from his pursuer. Nearby would be the sacred colors of gold and blue, purple and scarlet, the sweet-smelling incense, the bells and pomegranates, the vestments and other trappings. But none of these could avail for the person in deadly distress. The horns alone offered refuge. On the crude altar of the cross, Jesus made the great sacrifice so that we might take hold of Him and find refuge for our souls.

This title is associated with the events surrounding the Advent of our Lord. By the incarnation of Jesus Christ, God honored the human race. Others bestow an honor on us when they come to our home. When Christ, the Son of God, visited our earth, He paid the greatest honor to the human race. It eloquently proclaimed that God loves and cares for us. Christ became, in the miracle of the Incarnation, our Horn of Salvation. As such, He is our Protector, our Provider, our Harmonizer, and our Helper, as well as the Divine Guest.

Mighty Christ, turn my weakness into strength, my defeats into victory, my testings into triumph.

Portrait Fifty-Nine
LAMB OF GOD

Look, the Lamb of God, who takes away the sin of the world!
(John 1:29)

The portrait that John gives to us of Christ as the Lamb of God has its roots in the sacrificial system of the Jews. There were four kinds of sacrifices they offered to God: (1) libations or drink-offerings, (2) savor or incense-offerings, (3) vegetable or meal-offerings, and (4) animal-offerings. They are broadly classified as bloodless and bloody sacrifices. The animal sacrifices were distinguished as burnt-offering, sin-offering, peace-offering, and guilt-offering. Thus it was that on the altar of the temple there was always ascending the smoke from a carefully selected lamb or other innocent victim. Man realized that his guilt required expiation by blood. This was dramatically underscored in the unacceptable offering by Cain in contrast to the blood offering of Abel.

When Adam and Eve sinned we read that God Himself clothed them with the skins of animals (see Gen. 3:21). To do this it was necessary that some animal, perhaps a lamb, had to shed its blood to cover their shame. God declared in the levitical code that "it is the blood that makes atonement for one's life" (Lev. 17:11). So this scarlet thread is woven throughout the Old Testament until it takes us to Calvary's altar where we see the perfect Lamb of God sacrificed for the sins of the world. Never again would it be necessary for a lamb to be slain for the sins of man.

Not all the animals slain on Jewish altars would bring peace

to the guilty conscience or wash away man's stain of sin. But Christ as the heavenly Lamb, of noble sacrifice and divine blood, cleanses the sinner and makes him whole.

The Prince of the Prophets in the Old Testament graphically described the Lamb of God:

> He was oppressed and afflicted
> yet, He did not open His mouth;
> He was led like a lamb to the slaughter,
> and as a sheep before her shearers is silent,
> so He did not open His mouth.
>
> ISAIAH 53:7

In the New Testament, Peter reminds us that we were not redeemed with corruptible things but rather "with the precious blood of Christ, a Lamb without blemish or defect" (1 Peter 1:19).

From Adam all mankind has the heirloom of original sin. For the universal problem the sacrifice of Christ is the universal remedy.

But someone asks, "How can the sacrifice of One avail for all?" The answer is in the worth of the One who made the sacrifice. When Christ sacrificed Himself as the Lamb of God, it was not an ordinary man who died. It was God Himself. Thus His sacrifice has infinite merit.

Isaac Watts has expressed this theology in the hymn:

> Not all the blood of beasts
> On Jewish altars slain,
> Could give the guilty conscience peace
> Or wash away our stain.
>
> But Christ, the heavenly Lamb,
> Takes all our sins away,
> A sacrifice of nobler name
> And richer blood than they.

In Revelation, Christ is portrayed as the Lamb no less than 29 times by John the seer. But it is not the familiar figure found in the fourth Gospel. In fact, a different word is used for *lamb*

and Christ is portrayed as the exalted Lamb of God at the celestial throne who has accomplished the redemption of God's people. May we one day gather with that innumerable host around the throne of God and raise our voices in the great doxology to the Lamb of God: "Worthy is the Lamb, who was slain, to receive power and wealth and wisdom and strength and honor and glory and praise!" (Rev. 5:12)

Dear Lamb of God, I thank You for Your great sacrifice that avails for my guilt and sin.

Portrait Sixty
LIVING WATER

*If you knew the gift of God . . . you would have asked Him
and He would have given you Living Water (John 4:10).*

Water is vital and to be valued above all material things. Those
who heard Jesus refer to Himself as the source of Living Water
readily understood the pricelessness of water. They were sur-
rounded by arid land where people staked their lives and
futures on the small springs of water. Battles were fought to
retain a single well. Water was life itself.

T.S. Eliot in "The Waste Land" writes of despair as a deso-
late landscape where there "is no water but only rock." Later
when his life and poetry took on a Christian perspective, he
would write in "Ash Wednesday" of the One "who then
made . . . fresh the springs." We all linger in a spiritual waste-
land until we come to the One who offers Living Water.

When we go to our mountain retreat in the Catskills of New.
York, if we follow a certain path of the mountain it leads to a
spring that flows out of its rock-ribbed hill. It is a place to
pause amid its deep shade and moss-covered rocks and par-
take of its pure and refreshing treasure.

There is within each person a deep thirst that no earthly
spring can quench. But there is a well of pure water that comes
from a mountain. We must journey the path to Calvary and
then, as Isaiah promised, we will find: "With joy you will draw
water from the wells of salvation" (12:3). It is given by the One
who said: "If a man is thirsty, let him come to Me and drink.
Whoever believes in Me . . . streams of Living Water will flow

147

from within him" (John 7:37).

Have you been to the mountain? Have you tasted its waters?
God Himself invites us: "Whoever is thirsty, let him come; and
whoever wishes, let him take the free gift of the water of life"
(Rev. 22:17).

In our devotional aspiration, we would pray:

> When shall I come unto the healing waters?
> Lifting my heart, I cry to Thee my prayer
> Spirit of peace, my Comforter and Healer,
> In whom my springs are found let my soul
> meet Thee there.
>
> Wash from my hands the dust of earthly striving;
> Take from my mind the stress of secret fear;
> Cleanse Thou the wounds from all but Thee far hidden,
> And when the waters flow let my healing appear.
>
> Light, life, and love are in that healing fountain,
> All I require to cleanse me and restore;
> Flow through my soul, redeem its desert places,
> And make a garden there for the Lord I adore.

ALBERT ORSBORN

*Christ, our Living Water, You alone can satisfy the deepest
thirsts and yearnings of my soul.*

Portrait Sixty-One
SAVIOUR

This is indeed the Christ, Saviour of the world (John 4:42, NKJV).

This title was not a new word to the ancient world. Egyptian kings were called saviors. Some of the Roman emperors were designated by this title. But Jesus took this title and gave it new and eternal meaning.

In the New Testament this title is found most in 2 Peter where it is used of Christ five times. Peter knew Christ well as Saviour. There was that time when recklessly he started to walk out on the waves of the sea and, when suddenly his faith and then his foothold failed, he desperately cried out to Christ to save him. But there were other tempests from which Peter was rescued by Christ. There were the tempests within, when he was prone to base denial and faithlessness, and Christ saved him from disaster. Peter's steps seemed especially to be dogged by Satan who as a roaring lion sought to devour him, but his Master saved him. This became one of Peter's favorite titles for his Lord who had rescued him from so much.

When Lincoln's body was brought back by train to Springfield, Illinois, a former slave held her little child up to see the flag-draped casket containing the Great Emancipator's body. She said to her child, "Take a long look, Honey. That's the man who died to set us free." The title *Saviour* speaks of Christ's great sacrifice to save us from sin—its guilt, power, condemnation, eternal death.

At the Berlin World Congress on Evangelism in 1966, dele-

gates were deeply moved by the testimony of Kimo. Kimo was one of the Auca killers of missionaries 11 years before in the jungle of interior Ecuador. When asked in an interview: "What has Jesus done to change your life?" He answered, "I don't live the same way I did before. I don't live sinning now. Now I live speaking to God." Thus world leaders on evangelism witnessed a classic example of Christ's mighty salvation in the twentieth century.

There was once a gravestone which read, "Sacred to the memory of Methuselah Coney, who died aged six months." A name with a great meaning but unfortunately not fulfilled in the life of Methuselah Coney. There was no correspondence between the infant and the connotation of his name. Others in history had been called savior, but Christ alone was able to measure up to the full meaning of this title.

> I know a soul that is steeped in sin,
> That no man's art can cure;
> But I know a Name, a Name, a Name,
> That can make that soul all pure.
>
> I know a life that is lost to God,
> Bound down by things of earth;
> But I know a Name, a Name, a Name,
> That can bring that soul new birth.
>
> I know of lands that are sunk in shame,
> Of hearts that faint and tire;
> But I know a Name, a Name, a Name,
> That will set those lands on fire.
>
> AUTHOR UNKNOWN

Dear Saviour, I would be born twice so that I will die but once, rather than to be born but once and die twice.

Portrait Sixty-Two
JUDGE

*He is the One whom God appointed as Judge of the living and
the dead (Acts 10:42).*

We do not usually think of Christ as Judge. We prefer to linger
over the portraits of Him as Saviour, Good Shepherd, Lord,
Immanuel, Redeemer, Light of the World. But the title Judge is
a forbidding one. It is a dark and somber portrait we would
prefer to pass over.

But the Bible makes it clear that Christ will be our Judge.
Peter, in that epochal experience in the house of Cornelius,
preaches that "He is the One whom God appointed as Judge of
the living and the dead" (Acts 10:42). Paul in his memorable
message at Athens affirmed: "For He has set a day when He
will judge the world with justice by the Man He has appoint-
ed. He has given proof of this to all men by raising Him from
the dead" (Acts 17:31). And in his final charge to Timothy,
Paul wrote of "Christ Jesus, who will judge the living and the
dead" (2 Tim. 4:1). In the Gospels, Jesus Himself gives us a
"fast forward" view of the final judgment when from His
throne He will judge all nations (Matt. 25:31-32). In the final
book of the Bible, Christ is the One portrayed as the Rider on
the white horse of whom John the seer writes, "With justice
He judges" (Rev. 19:11).

The supreme sacrifice on Calvary requires a judgment. The
same cross that is a revelation of the love of God is also a
revelation of the wrath of God. Nowhere do we see the judg-
ment of God against sin as vividly as on Calvary. The flaming

sword at Eden's entrance, the raging waters of the Deluge, the blazing fires of Sodom—these and all God's pronouncements do not as unmistakably proclaim God's judgment against sin as does the Cross. The One who died on the cross to save us from our sin will one day judge us for our response to His salvation and the life we have lived.

We will each someday appear before the judgment throne of God. When we stand before Christ the Judge, may we be prepared by having known Him as Saviour and Lord so that we will hear His words, "Come, you who are blessed by My Father; take your inheritance" (Matt. 25:34).

> *Christ, who will someday be my Judge, help me to so live that I may hear Your, "Well done."*

Portrait Sixty-Three
OUR PASSOVER

Christ, our Passover Lamb, has been sacrificed (1 Cor. 5:7; see Ex. 12:1-27).

In our text, Paul allegorizes the memorial Passover feast with the Christian life. The Passover was a family feast that commemorated the deliverance of the Jews from Egypt. It called to mind the tenth and climactic plague when the firstborn of the Egyptians were slain. The angel of death passed over in recognition of the lamb's blood sprinkled on the doorposts and the Israelites were enabled to go forth from their bondage in Egypt. "Christ Our Passover" is a title pregnant with sacred meaning.

The Passover lamb had to be a "lamb from the flock." Christ came to the community of mankind. He became one of the "flock" of humanity. His Incarnation was a requisite to His work of redemption.

The lamb had to be a "male of the first year," in the prime of its life. Christ as a male was cut off in the prime of His life. He was not permitted to live out His life but was cut down at the height of His manhood.

It was required that the lamb be without blemish. This qualification excluded the blind, the broken, the maimed, the ulcerous, the scurvied, the scabbed, the bruised, the crushed, the castrated. No defects were allowed. So Christ was without stain, without spot, altogether pure and perfect.

Not a bone could be broken of the Passover lamb. On the cross in fulfillment of prophecy, and in keeping with this

typology, Jesus was spared the breaking of bones inflicted on the two malefactors. "I can count all My bones" (Ps. 22:17, AMP).

The Passover lamb was slain at eventide. The very hour that Jesus hanged on the cross is believed to have been the time the Passover lamb was slaughtered for this memorial feast. How perfect is God's timing! How inscrutable His ways!

The cooking of the lamb was done in a special manner over an open pit of glowing coals. The lamb was not allowed to touch the fire lest it be contaminated and have to be replaced. Two spits were put through the lamb, one lengthwise and the other through the side. The flesh would be riven but no bones would be broken. Thus every Jewish family hung its lamb on a cross of wood. This procedure for centuries foreshadowed the death of the Passover Lamb.

Those who applied the blood of the lamb were delivered from death in Egypt's land. Just so does He spare from eternal death those whose lives have had applied the blood of Christ, our Passover Lamb. In His blood alone is our deliverance from sin's bondage and our salvation from eternal death.

For seven days there followed the Feast of Unleavened Bread. The house was diligently searched by the light of a candle to be sure no leaven was in the house. If leaven were found in the house during that period, the people of the household would be cut off from the nation and their spiritual heritage. Those of us who have made our spiritual exodus out of Egypt's bondage, who have been delivered by Christ our Passover, need to search out every dark corner of our hearts to purge out the malignant leaven of sin and self. This tenement of clay must be cleansed lest sin corrupt the soul.

The Feast of Unleavened Bread celebrated the beginning of the grain harvest which 50 days later culminated in Pentecost or the Feast of Weeks. These festal observances become a parable of the soul. Christ would lead us from the Passover deliverance to the Pentecostal dynamic. Through the indwelling and ministry of the Holy Spirit, He would make our lives fruitful for Him.

Great sacrificial Lamb of God, I thank You for the salvation and security in Your blood shed for me.

Portrait Sixty-Four
ROCK

They drank from the spiritual Rock that accompanied them,
and that Rock was Christ (1 Cor. 10:4).

This text refers to the wilderness experience of the Hebrews
when twice from the smitten rock there was the gushing forth
of water to sustain and refresh them in an arid place. This
occurred at Rephidim (Ex. 17:1-6), which was the beginning of
the Exodus, and at Kadesh (Num. 20:7-11), which was near the
end of the Exodus wanderings. Paul indicates that the rock
smitten by Moses was a prototype of Christ. Spiritualizing the
historical experience he states, "that Rock was Christ": it was
emblematic of what He did for us.

In the passage of Exodus 17 we read, "The whole Israelite
community set out from the Desert of Sin. . . . But there was
no water for the people to drink." Man in his journey through
the "wilderness of sin" finds life spiritually arid and needs the
sustaining and refreshing water of life that Christ alone can
give. As the Israelites were revived and refreshed by God's
supernatural provision, so man's soul is revived and refreshed
by the provision Christ our spiritual Rock has made for us.

But the rock had to be smitten in order to give forth the
refreshing stream of water. Christ, our spiritual Rock, had to
be smitten in order for us to partake of the life-giving stream
that flows from His cross. Without His stripes we would have
no healing; without His sorrows we would have no balm;
without His thorns we would have no crown; without His
wounds we would have no healing; without His death we

would have no life. He is the "Rock of Ages" who was cleft for each of us.

This allegorical title for Christ has captured the imagination of inspired hymn writers who have given us expressions that will live on in the songs of Christendom: "On Christ the solid Rock, I stand," by Edward Mote; "Be our Rock, our Shield, our Tower," by William Pearson; "We have an anchor . . . fastened to the Rock which cannot move," by Priscilla J. Owens; "He hideth my soul in the cleft of the rock," by Fanny Crosby.

The rock has been the symbol of strength and endurance. Of Him the Christian can declare in confident testimony: "You are my Rock and my Fortress" (Ps. 71:3).

Toplady's hymn has been a classic because it gives expression to the meaning of this title in our lives:

> Rock of ages, cleft for me,
> Let me hide myself in Thee;
> Let the water and the blood,
> From Thy riven side which flowed,
> Be of sin the double cure,
> Cleanse me from its guilt and power.
>
> Not the labors of my hands
> Can fulfill Thy law's demands;
> Could my zeal no respite know,
> Could my tears forever flow,
> All for sin could not atone;
> Thou must save, and Thou alone.
>
> While I draw this fleeting breath,
> When mine eyes shall close in death,
> When I soar to worlds unknown,
> See Thee on Thy judgment throne,
> Rock of ages, cleft for me,
> Let me hide myself in Thee.

Rock of Ages, with the psalmist I would pray, "Lead me to the Rock that is higher than I." Help me to avoid the sinking sands of life and to build on You, who alone are the solid foundation.

Portrait Sixty-Five
THE LAST ADAM

*The first man Adam became a living being; the last Adam, a
life-giving Spirit (1 Cor. 15:45).*

Paul here portrays Christ as the "last Adam" and contrasts
Him with the "first Adam." The English translations give a
clue to the distinctions between the two Adams.

The "first Adam" is a "living soul" and the "last Adam" is a
"quickening Spirit" (KJV); the "first Adam" is a "living being"
and the "last Adam" is a "life-giving Spirit" (RSV); and the
"first Adam" is an "animate being" and the "last Adam" is a
"life-giving Spirit" (NEB). It is evident that Christ as the "last
Adam" brings a whole new and infinite dimension to man.

Paul says here that as Adam was the inaugurator of human-
ity (by divine fiat), so Christ was the inaugurator of eternal life.
As Adam was the progenitor of everyman's humanity, so
Christ is the Progenitor of our spiritual sonship. As Adam was
founder of the human race, so Christ ushered in the new order
of a spiritual race.

This title, set in Paul's great chapter on the Resurrection,
especially represents Christ bringing eternal life to the believ-
er. Prior to His mighty resurrection, man had no hope or
assurance for life after death. Death through the centuries, and
for many today, has been a haunting specter. We are each born
with an uncancellable contract with death.

An old Oriental legend tells that a wealthy merchant one
day sent his servant to the marketplace to secure

provisions for the household. The servant returned short-
ly, his limbs trembling and his face pale with fright.

"What is wrong?" exclaimed the merchant. "Master,"
cried the servant, "I just now met Death in the market-
place, and when Death saw me, he raised his arm to strike
me. Master, I am afraid, I must escape. Let me, I pray,
borrow your fastest horse, and I shall flee to Samarra."

The merchant, being a kindhearted man, gave his con-
sent, and the servant rode swiftly away to the city of
Samarra. After the servant had departed, the merchant
himself went to the marketplace. He too saw Death, and
going boldly up to him, said, "Death, why did you raise
your hand to strike my servant here in the marketplace a
little while ago?"

"Why," answered Death. "I meant him no harm—that
was a gesture of surprise. I was surprised to see him here
in Baghdad, for I have an appointment with him tonight
in the city of Samarra."

The realization that we are all without escape from the
ultimate claim of death imposes for many a certain fear
and anxiety.

Christ, the last Adam, once and for all answered the ultimate
question of death and gives life eternal to those who believe on
Him.

John Henry Newman has incorporated this title and the
truth it proclaims in his hymn:

> O loving wisdom of our God!
> When all was sin and shame,
> A second Adam to the fight
> And to the rescue came.
>
> O wisest love! that flesh and blood,
> Which did in Adam fail,
> Should strive afresh against their foe,
> Should strive and should prevail.

*Christ, Conqueror of death, raise me to the resurrection and
radiance of life divine.*

Portrait Sixty-Six
CHIEF CORNERSTONE

With Christ Jesus Himself as the Chief Cornerstone (Eph. 2:20).

Paul employed this architectural metaphor to indicate the relationship of Christ to His church and the believer. Christ spoke of Himself as a Temple and referred to the temple He would build made without hands (see Mark 14:58). He is the rejected Stone who became the Head Stone of the corner as spoken of by the psalmist (see Ps. 118:22). This metaphor conveys several significant aspects of Christ's ministry relative to His holy temple composed of the "living stones" of His believers.

A cornerstone would control the design of an edifice. From that point, an architect would plan and relate the balance of the structure. Christ as the Chief Cornerstone should determine the direction and design of our lives. He will give symmetry to life. A life that is linked to Him will be enhanced and ennobled. He will make all the parts of life contribute to the whole. He will help us maintain the many facets of life in proper proportion and perspective.

Another function of the cornerstone is to unite. One of the definitions of a cornerstone is a "stone which lies at the corner of two walls, serving to unite them." Paul writes of the Chief Cornerstone, "In Him the whole structure is joined (bound, welded) together harmoniously" (Eph. 2:21, AMP). Christ imparts a cohesiveness to the Christian community. We are the "living stones" of His holy temple that are united to Him and to each other.

159

The cornerstone holds the most honored position. Peter wrote: "To you who believe, this Stone is precious" (1 Peter 2:7). The word *precious* equates with *honor*. The cornerstone is the ceremonial block that is placed ritually in the outer wall bearing an inscription that memorializes the event and significant facts associated with the structure. Often the brick is hollow and is a repository of documents that will have future historical interest. This custom supposedly dates back over 50 centuries. The cornerstone held the most honored position in a structure. So the Chief Cornerstone holds the most honored position in a Christian's life—in our hearts, in our homes, and in our hopes.

The cornerstone was indispensable to the great temple of Solomon. The top plateau of Mount Moriah was not level or large enough for the total space required by the resplendent temple. Thus the Israelites ingeniously constructed a large cornerpiece of heavy masonry that reached up from the plunging valley below and with this held up part of the illustrious temple. To an observer it would seem as though that cornerpiece was holding up the temple. We would be God's holy temple, sacred and indwelt by His Spirit. Our lives are quarried from a natural rock which of itself is not sufficient. But our sufficiency and our completeness come from the upholding power and presence of the Chief Cornerstone. From Him, our lives derive strength and support.

We affirm, in the words of John Chandler's song:

> Christ is our Cornerstone,
> On Him alone we build;
> With His true saints alone
> The courts of heaven are filled.
> Our hopes we place on His great love
> For present grace and joys above.

Christ, be the Cornerstone of my thoughts, my deeds, my life. Then will it have spiritual symmetry and significance.

Portrait Sixty-Seven
HEAD

Speaking the truth in love, we will in all things grow up into Him who is the Head, that is, Christ (Eph. 4:15).

Paul was calling the Christians at Ephesus to maturity in Christ, to "reach unity in the faith and in the knowledge of the Son of God and become mature, attaining to the whole measure of the fullness of Christ" (v. 13). He goes on to say that we are not to remain in spiritual infancy, unstable and gullible, but committed to the truth and "in all things grow up into Him who is the Head, that is, Christ" (v. 15).

Maturity and the headship of Christ are intertwined in the Christian life. When we try to lead our own lives and do not acknowledge His authority, we live in spiritual immaturity. It is only when Christ is our Head, our Leader, our Authority, that we grow to maturity in Him. There is no growth apart from Him; it is always as the verse states, "when we grow up into Him."

The title "Head" denotes preeminence. Christ must be our first priority, our Sovereign as well as our Saviour. Augustine summarized this truth in his statement: "Christ is not valued at all unless He be valued above all." Albert Schweitzer called Christ "an Imperious Ruler" and went on to say that as we obey His commands we come to know the enrichment and strengthening of His fellowship.

There are some who have authority by conferment—it comes to them from without. They may or may not measure up to the trust and responsibility of the power vested in them.

Then there are others who have authority by virtue of their character and leadership, with or without the conferred status. They have respect and a following because of who and what they are. With these few people along life's road, it is not a burden but a privilege to serve under their leadership. Their wisdom, integrity, fairness, sensitivity, and love make it a joy to follow them and be under their leading.

Jesus Christ is our Head, with both conferred authority as the Son of God and earned authority for His infinite love and goodness. The highest privilege of service is under the headship, the divine authority of Jesus Christ. As Paul describes in his expanded metaphor (v. 16), when we have the Lord as our Head, then there is symmetry, harmony, and efficient function. May we know Him as our living Head—our Leader and ultimate Authority.

Christ, our Living Head, help me to know true liberty that comes alone from surrender to Your will and way.

Portrait Sixty-Eight
THE HEAD OF THE CHURCH

Christ is the Head of the Church (Eph. 5:23).

Paul, in Ephesians 1:19-23, writes of the ascended and exalted Christ enthroned at the right hand of God and dwelling in heavenly places in universal conquest. The culminating thought is, "And God placed all things under His feet and appointed Him to be Head over everything for the church, which is His body, the fullness of Him who fills everything in every way" (vv. 22-23). Paul uses a physiological metaphor to express a stupendous thought—Christ is the Head and the church is the body.

What is the church? It was once my privilege to tour some of the world's great cathedrals. One is greatly enriched by visiting the renowned cathedrals of Rome with their sacred history and graced by the works of some of the world's greatest artists and sculptors. In addition to the great cathedrals of Rome, the Quo Vadis Chapel on the Appian Way speaks volumes to the heart of the spiritually sensitive tourist. In Paris, Notre Dame has a mystical quality all its own. Majestic St. Paul's in London strikes many responsive chords in the heart of the visitor. At St. Giles in Edinburgh, one can imagine John Knox thundering forth his reformation sermons amidst the great Gothic pillars. Perhaps our most deeply stirring experience was the visit to the new cathedral at Coventry, replacing the one bombed in the blitz of the War. Its contemporary architecture and modern programs eloquently proclaim the Christian faith.

But these edifices with their worshipful features, and their unique spiritual aesthetics, as superb as they are, do not comprise in themselves, the church. The church is something bigger, more vibrant than all these things. It is more than a cathedral or an organization.

A watch is an organization. It is made up of many parts all functioning in coordination in its intricate mechanism. But it is inanimate. The body also has a coordinating function. However it is more than an organization, it is an organism. Each part is alive and mutually dependent and contributing. So the church is a living organism. Christ is its Head. The company of believers is the body.

As the Head of the church, Christ is its Leader and its Authority. His presence rules its policy and its practice. As the Living Head His presence is realized by those who enter into the corporate experience of worship.

The phone of a church in Washington rang and an eager voice inquired, "Do you expect the President to be in church tomorrow?" The answer, "Not sure. But we expect Christ to be here and that is a reasonable incentive to bring a large congregation of people." Only when the presence of Christ is realized and He is truly the Head, do we have, in actuality, the true church.

The Scripture gives us a related discourse on the church with Paul using a nuptial symbol in designating the church as the bride of Christ (see Eph. 5:23-33). Marriage implies a sacred union. Thus is symbolized the sacred union between Christ and His followers. Marriage requires a mutual fidelity. Christ cannot and will not be faithless to us. May we be faithful to Him. Marriage involves a sacrifice: "Christ also loved the church, and gave Himself for it." Have we made the sacrifice of ourselves to the claims of His great love?

Christ, who gave Yourself in love for the church, help me to be a faithful member of the body of believers that acknowledge You as its exalted Head.

Portrait Sixty-Nine
LORD

And every tongue confess that Jesus Christ is Lord, to the glory of God the Father (Phil. 2:11).

This is one of the most common titles for Christ. Its use had a gradual growth until by the time Paul wrote his epistles he uses this title over 200 times. It had both a human and a divine connotation, the latter becoming more pronounced following the Resurrection. It is probably the most theologically significant of all the titles of Christ.

The *Greek-English Lexicon* of W.F. Arndt and F.W. Gingrich suggests at least eight usages of this very sacred and significant title, *kurios*.

Kurios denoted the *owner* of possessions such as the owner of the vineyard (see Matt. 20:8) or the master of the house (see Mark 13:35).

As the Lord of the universe, "He has the whole world in His hands." The infinite depth of the universe is His habitation. This pygmy planet is just a speck in the universe of His green footstool. The imagination is staggered at the thought of His proprietorship in the cosmos. Yet, wonder of wonders, He holds my life in His mighty hands. The Lord of the universe is the Lord of my life.

This title also speaks of the *authority* of Jesus Christ. With the voice of authority, He commanded the raging wind and waves to be still. With the voice of authority, He brought forth Lazarus from his tomb. He demonstrated His authority over death and the grave by the mighty act of His resurrection. In

the authority of Jesus Christ there is security for the soul and its commitment.

Kurios was often used as an opposite to *doulos* or slave. Paul referred to himself as a "servant of Jesus Christ." But it was a joyful status. The paradox of the Christian life is that only when we become His servant do we have freedom; only when we surrender do we have victory; only when we die to self do we find life.

This title was also the designation of any person of high position. It was my privilege to make a personal pilgrimage, as have so many others, to Stratford-on-Avon. There, one is inspired by the thought of a man who, writing with a whittled quill by the light of a tallow candle, produced lines that will be read and spoken until the end of time. If Shakespeare were to walk into any room today, everyone would stand up. But if Jesus Christ were to walk into a room, everyone would kneel. He towers above all other personages as the Peerless One of history.

Kurios was also used as a title for other supernatural beings (see Acts 10:4). We know not what other forms of beings exist in God's world, but the Bible does tantalize our imagination with hints of otherworldly life. All other celestial beings are but His couriers and are under His universal lordship.

Kurios was also applied to *deified rulers* (see 25:26), and in particular, to later Roman emperors. But their glory was short-lived. Christ alone was great enough to fill this title.

Most important of all, *kurios* was a designation for God (see Matt. 5:33). It was the Greek translation of the sacred name Jehovah or Yahweh in the Old Testament. This title following His resurrection had a tremendous significance when applied to Christ. It equates Him to a Member of the Godhead. It is a recognition of His divinity.

"Jesus is *Kurios*" became the confession of the (Pauline) Christian church: "That if you confess with your mouth, 'Jesus is Lord' . . . you will be saved" (Rom. 10:9). "And every tongue confess that Jesus Christ is Lord, to the glory of God the Father" (Phil. 2:11). The creed of the early church was not a what but a whom.

Infinite Christ, I would crown You Lord of my life, Lord of all.

Portrait Seventy
ALL IN ALL

Christ is All and in all (Col. 3:11, NKJV).

Paul laid down the rules of the Christian life in his Letter to the Colossians. Christians are to "set your minds on things above, not on earthly things. For you died, and your life is now hidden with Christ in God" (vv. 2-3). A radical transformation is required with the need to "Put to death, therefore, whatever belongs to your earthly nature" (v. 5).

The apostle leaves no doubt what some of those things are as he gives a catalog of the sins that were compromising those within the church (vv. 5-9). The list, unfortunately, has not become outdated. Immorality, selfishness, greed, anger, slander, deception still need to be "put to death" and then we are to "put on the new self, which is being renewed in knowledge in the image of its Creator" (v. 10).

Paul seems to summarize his teaching on the Christian life with the sweeping statement "Christ is All and in all" (v. 11, NKJV). In other words, he is saying, "Your Christian life cannot be a halfhearted, lukewarm, fickle, inconstant thing. It demands total commitment. Christ is not to be just a part of our lives, but He is to be our All. To the Christian, Jesus is not something, He is everything; He is not in part of his life, He is in all of his life—He is All in all."

In a sense this title is a summary of all the titles of our Lord. He is our All in all—our Saviour, Peace, Teacher, Light, Friend, Hope, Lord, King, Guide, Shepherd, God.

There is a wholeness about the life of Christ that the Christian needs to experience. His birth that evokes such a grand celebration is incomplete without His mighty life and teachings. His life is incomplete without His death, and His death without His resurrection, and His resurrection without His ascension, and His ascension without His coming again. His life is as a tapestry. The tapestry must be looked on as a whole to see its design and beauty. We need to know Christ as our All to know the fullness of His presence and power in our lives.

One book of Christian songs has no less than 12 different entries that refer to this title, All in all. A verse by Herbert H. Booth is a prayer for Christ to be our All in all:

> I bring to Thee my heart to fill;
> I feel how weak I am, but still
> To Thee for help I call.
> In joy or grief, to live or die,
> For earth or heaven, this is my cry,
> Be Thou my All in all.

Lord Jesus, be my All in all.

Portrait Seventy-One
OUR HOPE

Christ Jesus our Hope (1 Tim. 1:1).

"Hopeless" is one of the saddest words of the English language. Hopelessness impinges on us every day from the media and from our own encounters with life. An illness, without hope of recovery. A departure, without hope of return. People trapped, in a mine shaft or a mountain avalanche, without hope of rescue. A child lost, without hope of being found. A nation of people under Communist rule and suppression, without hope of liberty.

Mankind was lost in sin. The divine pronouncement was death, a holy and righteous God could not tolerate sin in His Creation. Sinful man was doomed. There was nothing he could do to save himself. He was helpless. But he was not hopeless. God provided a way. William Hawley's verse expresses in simple, yet sublime words this truth:

> A light came out of darkness;
> No light, no hope had we,
> Till Jesus came from heaven
> Our light and hope to be.

In his epistles, Paul writes of "Christ Jesus our Hope" (1 Tim. 1:1) and "Christ in you, the Hope of glory" (Col. 1:27). In his letter to Titus, he refers to the return of our Lord as "the blessed Hope" (2:13). We need never despair—Christ is our

Hope. The writer of Hebrews assures us with his marine metaphor that Christ is sufficient for all the storms and stresses of life for "we have this Hope as an anchor for the soul, firm and secure" (6:19).

How precious is this hope when we say a final good-bye to our loved ones. In the words of Paul, we do not "grieve like the rest of men, who have no hope. We believe that Jesus died and rose again and so we believe that God will bring with Jesus those who have fallen asleep in Him" (1 Thes. 4:13-14).

Our songs of faith pulsate with this hope we have in Christ. With R.H. McDaniel we affirm, "I'm possessed of a hope that is steadfast and sure, since Jesus came into my heart." The words of Bernard of Clairvaux are as true today as when he wrote them centuries ago, that Christ is the "Hope of every contrite heart." With Edward Mote, we sing in confidence for this life and beyond the grave:

> My hope is built on nothing less
> Than Jesus' blood and righteousness,
> I dare not trust the sweetest frame,
> But wholly lean on Jesus' name.

Dear Lord, thank You for the sure and certain hope we have in You, for the needs of this life and for life to come.

Portrait Seventy-Two
MEDIATOR

For there is one God and one Mediator between God and men, the Man Christ Jesus (1 Tim. 2:5).

In New Testament times, a mediator or a *mesites* was commonly known among the people. He was the one who came between two parties who had a dispute or a difference. He was the middleman who would arbitrate between the separated and contesting parties or persons. Today the word *mediator* still means "one who brings about an agreement between two parties at variance."

In the Old Testament, we hear the plaintive cry of Job, "Neither is there any daysman betwixt us" (Job 9:33, KJV). The word *daysman* in the Septuagint is the same word of our text translated *mediator*. Job in his desperate crisis longed for someone who could mediate between him and God. Job's yearning had to go unsatisfied. But in Hebrews 12:24 Christ is called the Mediator of the New Covenant. In our text, Paul declared that Christ is the only Mediator between God and men.

Christ fulfilled two vital functions as Mediator. A mediator has to be able to *represent* both parties. Christ represented both God and man. He represented God as a Member of the Godhead. He alone was able to represent the cosmic presence. Because He had come from the courts of God, He could represent the eternal council of God.

The miracle of the Incarnation also qualified Him to represent man. He was clothed in the garb of humanity. He carried man's burdens, endured man's agony, suffered man's

sorrows, was tested by man's trials and temptations, lived as a man among men, and died a man's death. He was the Infinite who had become the Intimate, the divine Sovereign who became the human sufferer. Thus He was able to represent man.

In the days of Ezekiel the prophet, the people to whom he spoke were exiles in Babylon. They were refugees of war, dispossessed of their country, their homes, their freedom. The prophet wanted to give them a message of comfort, of hope. Before Ezekiel could encourage them with his vision, he had to know himself something of the depths of their despair.

So the prophet of the Exile went down to Babylon to live where they lived, to be a captive where they were captives, to feel himself their sorrows and humiliation. Then he could say, "I sat where they sat." Then his message had authority because it was forged in the fires his people were experiencing.

Our Lord is a Mediator who has sat where we sit. He Himself came down and endured our sorrows, our sufferings, our humiliations, our limitations. His message to us and His mediatorial role has infinite authority for us.

A mediator also has the task of *reconciliation*. This was the second vital function of Christ as Mediator. God did not need to be reconciled to man. God has always been seeking man out. He is the eternal lover of man's soul. He is the hound of heaven who has ever been pursuing man to restore the broken relationship. Man is the renegade. Man is the one who has been disloyal to the love and fellowship of God. Jesus' role as Mediator is to bring man back into relationship with God.

There was only one way He could effect this reconciliation. That was the awful price of the Cross. Man's rebellion had stamped on it the penalty of eternal death. God in His righteousness decreed that without the shedding of blood there would be no remission of sin. The way of the Cross was the only way to reconciliation. The Cross was the great bridge from earth to heaven. It spanned the deep chasm of sin. It is the place where the broken relationship is restored. "God was reconciling the world to Himself in Christ" (2 Cor. 5:19).

Divine Mediator, keep me in fellowship and faith with my Creator.

Portrait Seventy-Three
RANSOM

Christ Jesus, who gave Himself as a ransom for all men
(1 Tim. 2:5-6).

We know the value of a piece of property only when we have a cash offer to buy it, an offer from a person or firm of integrity. We can know the value of our soul only when we see the price God paid on the cross to purchase our salvation. Paul makes a public record of that price in his statement: "Christ Jesus, who gave Himself as a ransom for all men" (1 Tim. 2:5-6).

A strange title, when you think of it, for the Son of God. "Ransom" is the price paid or demanded to redeem or release a captive. It is a term we usually associate with kidnappers, terrorists, hostages, and the world of human violence. Fortunately, not many of us are touched in this way. Or are we?

We were taken captive, a helpless hostage, under the sentence of eternal death. The cost for our redemption was beyond the means of any mortal. "The price of sin" and its payment by our Lord is expressed in the words of Cecil Alexander we sing devotionally:

> There was no other good enough
> To pay the price of sin;
> He only could unlock the gate
> Of heaven and let us in.

Dear Saviour, Your love so amazing, shall have my all.

173

Portrait Seventy-Four
BLESSED AND ONLY POTENTATE

He who is the blessed and only Potentate, the King of kings and Lord of lords (1 Tim. 6:15, NKJV)

In his doxology, Paul exalts "He who is the blessed and only Potentate, the King of kings and Lord of lords" (1 Tim. 6:15). These titles may well have been in opposition to the cult of emperor-worship that Christians were compelled to resist. Christ alone is Ruler and Sovereign over all earthly rulers.

A potentate was a monarch or ruler having great power. The word calls to mind such as Kublai Khan, the great Mongol of China, and more recently, Stalin and Hitler, who claimed such power. Often these rulers were feared and ruthless, illustrating Lord Acton's adage: "Power corrupts, and absolute power corrupts absolutely." None of them could have had the word *blessed* before their name. In all history, only Christ could be called a blessed Ruler. He is the Ruler who brings blessing, goodness, and peace.

In that day when our Lord cast His shadow on earth, all eyes were on Rome. There was the pomp and power, the greatness and glory. A pompous Caesar named Augustus decreed a census to enlarge his tax base. No one took much notice of a man and his pregnant wife making their journey to be registered with hordes of others. In the miraculous workings of God, that mighty emperor was merely a pawn for that moment of time, a piece of lint on the pages of history, a footnote in the chronicles of prophecy. That woman gave birth to a Son who would become the hinge of human history and of whom 2,000

years later His followers would sing:

> Jesus shall reign where'er the sun
> Does His successive journeys run:
> His kingdom spread from shore to shore,
> 'Til moons shall wax and wane no more.
>
> <div align="right">ISAAC WATTS</div>

Christ, rule supremely over my life that I may know Your blessing and peace.

Portrait Seventy-Five
THE KING OF KINGS

God, the blessed and only Ruler, the King of kings and Lord of lords (1 Tim. 6:15).

Paul calls forth his highest superlatives to try to describe and define Jesus Christ. Compared to the brightness of His majesty all other kings are only as smoking flax vainly endeavoring to illuminate the noontide.

Shelley, in one of his sonnets, speaks of meeting a traveler from Egypt. In the desert, the traveler had found the remains of a statue, with two trunkless legs, and near them a broken face. On the pedestal was this inscription:

> My name is Ozymandias, king of kings:
> Look on my works, ye Mighty, and despair!

Ozymandias had the effrontery to style himself "king of kings," but he left behind him only remnants of legs and a broken visage in stone.

Jesus in His unapproachable glory as King of kings left behind Him an eternal kingdom. Let us consider certain aspects of His kingship.

Every king must have a *right to the title*. The universal requirement for kingship has been royal blood. There must be royal blood coursing through the veins of the one who would ascend the throne. Earth's monarchies and dynasties have had a succession by royal lineage.

Matthew, the genealogist, carefully traces the Davidic de-

scent of Jesus. To many minds, it was necessary to certify in this manner the messiahship of Jesus. However great was Christ's descent from Israel's illustrious king, His title to kingship does not rest on such an earthly and decaying foundation. Jesus is the King of kings not because He is the Son of David but because He was and is the Son of God. His kingship rests on the eternal foundation of His divinity. His divine right was based on His divine character.

Every king has a *throne*. In the part of majestic Westminster Abbey known as St. Edward's Chapel, there is what many consider to be England's most precious relic, the ancient Coronation Chair. It dates from the time of Edward I in 1300 and has been used for every coronation since that time. It was made to hold the historic Stone of Scone which is in repose at the base of the chair. As I looked at that chair, my imagination suddenly came under the spell of the illustrious array of queens and kings who sat on that throne in their brief moment of glory and grandeur.

What about the throne of the King of kings? Is there no throne of grandeur for the Lord of the universe? The Scripture gives us our answer: "Heaven . . . is God's throne" (Matt. 5:34). "Jesus . . . is set down at the right hand of the throne of God" (Heb. 12:2, KJV). Jesus today reigns from the celestial, unfading, eternal throne of God in heaven.

There is another throne that needs to come under the lordship of Jesus Christ. It is the throne from which there issues all the orders of life—the throne of the human heart. Does He reign without a rival on the throne of your heart?

Every king has *power*. Jesus alone could make the claim, "All power is given unto Me" (Matt. 28:18, KJV).

Every king has *subjects and a kingdom*. Jesus said, "My kingdom is not of this world" (John 18:36). While other kingdoms fade and vanish, the eternal kingdom of Jesus Christ continues to expand.

Many have given their lives at the command of an earthly king. Have you given your heart, your life to Jesus—the King of kings, the blessed and only Potentate, and Lord of lords?

Lord of lords, and Kings of kings, rule supremely on the throne of my life.

Portrait Seventy-Six
PIONEER OF OUR SALVATION

But it was fitting that He, for whom and by whom all things exist . . . should make the Pioneer of their salvation perfect through suffering (Heb. 2:10, RSV).

The soul of our nation was stirred and seared as we saw the feathery flame explode spacecraft Challenger, and its seven heroes of the heavens vanish into the fiery nightmare on January 28, 1986. We mourned the loss of the courageous crew who had dared to break the bonds of earth, and solemnly watched as our President led the nation in mourning. School-teacher Christa McAuliffe of that crew had caught the imagination and won the heart of America. She ventured toward the heavens with her son's stuffed frog, her daughter's cross, her grandmother's watch, and a lesson to beam back to her class on earth. As an "innocent aboard," her death seemed doubly poignant.

Not long before her ill-fated launch, Christa McAuliffe had taken time to write to the Sunday School of the Manchester, New Hampshire Salvation Army. She commended the members of that Sunday School and then challenged them not to "get stuck with what is comfortable," but be willing to "venture into the new." She was a teacher who unforgettably modeled her lesson, a pioneer in spirit as well as in space.

To be a pioneer requires great courage, a willingness to take risks and to go where others have not gone before. It has its demanding disciplines and may exact a costly sacrifice.

Christ is called the "Pioneer of our salvation" (Heb. 2:10, RSV). On our behalf, He ventured where no one had ever gone

179

before. For our sake, He took on Himself the demanding disciplines and made the costly sacrifice of His life and crucifixion.

Our text in Hebrews teaches that it was His suffering that made Him perfect as the Pioneer of our salvation. This does not refer to the perfecting of His personal holiness but to His qualification as our Saviour. It was by His suffering and death that He would redeem us from our sin.

Nothing less than His sacrifice would suffice for our salvation. The scarlet payment on the cross alone would satisfy the demands of God's justice for atonement. Had a million suns with their incalculable fires been a sufficient offering, God the Father would have summoned them to illuminate the universe with His altar fire.

Christ as the Pioneer of our salvation made the longest journey of all to rescue us from Satan and sin. He is the cosmic Christ who came through the vast intergalactic reaches of the universe, touching down at Bethlehem, and paying the ultimate price of His journey on Calvary's hill. But by His mighty power He rose again and made His return to heaven from the Mount of Olives where one day He will make His reentry as our reigning Lord to the acclamation of heaven and earth.

Pioneer of our salvation, thank You for the long and sacrificial journey You made on my behalf, and for the assurance of Your return.

Portrait Seventy-Seven
APOSTLE OF OUR PROFESSION

Consider the Apostle . . . of our profession, Christ Jesus
(Heb. 3:1, KJV).

Apostle means the one sent. This title implies a direct commission from God. There were other apostles, but Jesus was sent of God in a way unlike that of any other.

This title suggests two things about Christ. He was sent. We ask, "By whom?" Thus the title suggests the *Person* who sent Him. Divine imprimatur was on His mission. "God was in Christ."

In the fourth Gospel, Jesus uses the expression, "He who sent Me," 26 times. He also uses a synonymous verb 182 times in reference to His mission from the Father.

This term does not detract from the voluntariness of Jesus' coming. Jesus said, "I lay down My life. . . . No one takes it from Me, but I lay it down of My own accord" (John 10:17-18). His compulsion was His compassion.

His Advent was not an emergency measure of God to meet a sudden calamity. Before time commenced its solemn march, God's love anticipated man's need. We read in Revelation 13:8, KJV, that Jesus is the "Lamb slain from the foundation of the world." Christ's redemptive mission was not an afterthought of God, but was prearranged in the councils of eternity. God is omniscient. He is prescient. He foreknows and foresees the future. Christ was sent as an Apostle by God. His mission was determined and dedicated before the Creation of our world, before Adam and Eve, before the Fall.

Paul declares: "[He] made Himself nothing, taking the very nature of a servant" (Phil. 2:7). The servant's role was voluntarily assumed to accomplish the great work of redemption. No theologian can fathom the mystery and majesty of Christ's renunciation to become a Servant. No mystic can plumb its depths of devotion. Christ went from riches to rags that we might go from rags to riches. He became bankrupt that we might inherit His imperishable riches. He descended the steps of glory that we might ascend with Him to worlds unknown. He became a pauper that we might become princes. He became what we were that He might make us what He is.

This purpose of His coming is expressed simply, yet sublimely, in the verses of song by Emmanuel Rolfe:

> Jesus came down my ransom to be;
> O it was wonderful love!
> For out of the Father's heart He came,
> To die for me on a cross of shame,
> And from sin's bondage to reclaim;
> O it was wonderful love!
>
> Clear to faith's vision the Cross reveals
> Beautiful actions of love;
> And all that by grace e'en I may be
> When saved, to serve Him eternally;
> He came, He died, for you and me;
> O it was wonderful love!

Does this title suggest another scriptural truth for our consideration? Jesus said to His followers, "As My Father hath sent Me, even so send I you" (John 20:21, KJV). Christ was an Apostle, sent by God the Father to men. Now, in His physical absence from this world, He depends on us to make known God's Word and will to men. Will you be as *one sent* by the Master? Will you accept the challenge?

Thank You, Lord, for coming to our troubled and tortured world. Let not Your sacrifice for me be lost and let not Your image in me die. Help me to proclaim the immortal message.

Portrait Seventy-Eight
HIGH PRIEST

He has become a High Priest forever, in the order of Melchizedek (Heb. 6:20).

Christ was, on our behalf, a High Priest. Verse 19 tells us He "enters the inner sanctuary behind the curtain." It is referring to the holy of holies which represented the very presence of God. Previously only the high priest of the Aaronic order could go into the holy of holies, and he but once a year. He went as the representative of the people. They could not go after him, but Christ went as the High Priest and opened a direct access to God for us. No longer is there required a human intermediary. The veil was rent in two. The middle wall of partition was broken down. Christ conferred the sacred privilege of the priesthood on all believers.

The writer declares that Christ is a High Priest of a new and different order from that of the religious system of the Levites. He is of the order of Melchizedek. The name slips into the Bible narrative in Genesis 14:18-20. In Hebrews 7, the superiority of Melchizedek is delineated by Abraham's payment of tithes to him. This placed the great patriarch in an inferior position to Melchizedek. The psalmist prophesied of the Messiah: "Thou art a Priest forever after the order of Melchizedek" (110:4, KJV). Thus was Melchizedek a prototype of the Great High Priest who was yet to come.

Melchizedek had *no recorded beginning or ending.* Thus is symbolized the eternal priesthood of Christ. Other priests held their office for only a transient period and then would be

succeeded by another. Christ's is a perpetual priesthood.

Melchizedek had *no recorded parents.* The record of parentage was the *sine qua non* for the levitical priest. His ancestry was the primary criterion for his office. But Melchizedek was not a priest by pedigree. Neither was Christ a Priest by descent from the tribe of Levi. He was of the tribe of Judah and represented a new and higher order of priesthood.

The name Melchizedek meant King of Righteousness. He was also the King of Salem which meant peace. Christ is also the King of Righteousness and the King of Peace. These two great qualities will characterize the new kingdom He will usher in when He returns to take His kingdom and His crown.

One of the primary functions of the high priest was intercession for the people. On his shoulders were 2 onyx stones with the names of the 12 tribes inscribed on them. Also, on his breastplate were 12 stones with the names of the 12 tribes. Israel was represented on the shoulders of his strength and the heart of his love. Christ, our Great High Priest, on the shoulders of His omnipotence and on His heart of infinite love carries our names and our needs into the presence of God.

Christ is our Great High Priest by the efficacy of His atoning sacrifice. In Hebrews 9:4, there is described the furnishings of the holy of holies: the golden censer, the ark of the covenant overlaid with gold containing the golden pot that had manna, Aaron's rod that budded, and the Ten Commandments. But there is one piece of furniture that significantly was not included. That was a chair—for the work of the high priest was never finished. Year after year, on the Great Day of Atonement, he would again have to enter the holy of holies and offer his sacrifice. However, we read of Christ and His sacrificial work, "But when this priest had offered for all time one sacrifice for sins, He sat down at the right hand of God" (10:12). He alone could say of His priestly work of atonement, "It is finished."

Our scriptural context also declares the extent of His atoning work: "Therefore He is able to save completely those who come to God through Him, because He always lives to intercede for them" (7:25).

Christ, my Great High Priest, I thank You for opening the
new and living way to God for me.

Portrait Seventy-Nine
GUARANTEE OF A BETTER COVENANT

Jesus has become the Guarantee of a better covenant (Heb. 7:22).

A covenant is an agreement between two people, that if one faithfully performs certain requirements, the other will respond in a certain way. There was the Old Covenant, based on keeping the Law. That covenant was between God and Israel, and is the basis of the Old Testament. The New Covenant, between God and man, promises access to God through Christ, and is the basis of the New Testament.

And how do we know we have access to God, that He accepts our faith and devotion? The writer of Hebrews assures us: "Jesus has become the Guarantee of a better covenant (7:22). This title is also translated "surety" (NKJV, RSV). A surety was one who gave security, who was surety, who stood guarantor.

Living with guarantees is common today. There are guarantees for credit, for quality and life of goods, for contracts and transactions of many kinds. A guarantee assures that something will be paid, someone will be satisfied, some undertaking will be honored. But the guarantee is only as good as the integrity and capability of the guarantor.

Jesus is the Guarantor of the love of God, of our salvation, of God's promises, and of life eternal. Surely we have One whose integrity and capability can, without a doubt, be depended on. That is why Christians sing in confidence the familiar words of Fanny Crosby:

185

Blessed assurance, Jesus is mine;
 O what a foretaste of glory divine!
Heir of salvation, purchase of God,
 Born of His Spirit, washed in His Blood.

*Thank You, Lord, for Your guarantee of my salvation—not
for any limited period, but for eternity.*

Portrait Eighty
PIONEER OF OUR FAITH

Looking to Jesus the Pioneer . . . of our faith (Heb. 12:2, RSV).

The Greek word applied to Christ in this verse had a many-splendored association. This word, *archegon*, is made up of *age* meaning "to lead," and *arche* meaning "the first." This compound word means the chief leader or one who takes the lead in something and provides an example. This word is variously translated as Prince, Captain, Author, Leader, Chief Leader, Guide, Source, Prince.

Perhaps the word *pioneer* translates its meaning best in representing Christ as the One who has gone ahead and blazed the trail for us to follow. He is our great Trailblazer who has gone on in the way that was previously untrod. He has opened for us new frontiers and new worlds that beckon us to follow in the trail He has blazed.

A pioneer is a person who goes before, preparing the way for others. History books are replete with the exploits and explorations of pioneers. There are those who pioneered the earth and the seas, those who unlocked the secrets of nature, those who have been pioneers in the shaping of society. In our day we have a new breed of pioneers, space explorers who are opening new worlds and expanding our knowledge of the universe.

There are pioneers of geography, of nature, of society and of space—but there is another realm more vital to each person— the universe of the spirit. We need someone to go before us, to

unlock the mysteries of the spiritual realm, to help us discover its secrets, to blaze a path so we may follow. The title of our Lord in this text tells us He is *The Pioneer of our faith.* He has gone before us in the spiritual realm. The secret of success on the pilgrimage of life is to follow in His steps.

As the Pioneer of our faith, He has opened for us the path that leads to abundant, vibrant, victorious, fulfilling, and eternal life. He leads us forth from the hinterlands of mere existence to the frontiers of exciting discoveries and delights.

In Hebrews 2:10 (RSV), Christ is portrayed as the *Archegon* or Pioneer of our salvation. His path led to the agonies suffered in the shadows of Gethsemane. He trod in deep sorrow the Via Dolorosa. He trekked up the lonely and torturous path that led to Calvary. He traveled down the dark and desolate road that led to our salvation. But He returned with the gleaming keys of salvation and eternal life at His side. He opened for us the doors to heaven.

In Hebrews 11, we are given the roll call of faith in this Westminster Abbey of the Bible. Christ is the Chief Leader of our faith. We need to keep our eyes fixed on the Pioneer of our faith in order to avoid the distractions and detours that will prevent us from reaching our goal in the great race of life.

This last text gives us a compound title: "The Pioneer and Perfecter of our faith." He who has originated, authored, and pioneered our faith will also perfect it. He has not deserted life's path and those who travel on it. His presence and His resources enable us to go all the way with Him to fulfill life's ultimate design and reach life's ultimate destination.

In a sense, we are all pioneers. Each one has before him a life that is uncharted. We are blazing an individual path of life where no one has ever gone before. We may go safely and successfully if we follow One who has gone before and prepared the way for us.

Pioneer of the way that lies before me, give endurance to follow You all the way.

Portrait Eighty-One
JESUS CHRIST

Peter, an apostle of Jesus Christ (1 Peter 1:1).

The double title "Jesus Christ" has meaning over and above the titles used separately. "Jesus" is our Lord's human name and "Christ" is His divine name. Thus the two link His humanity and divinity. When used in combination, as in the signature at the opening of Peter's epistles, it is an acknowledgment of our Lord as man and God

Peter knew the Lord in His humanity. He was privileged to share intimate companionship, to witness firsthand His astonishing life and ministry on earth. He knew the Lord in His divinity. He witnessed the drama of our Lord's mighty miracles and the astonishment of His deeds.

This disciple had reason to be grateful for the special understanding the Lord would have of him, having been human and knowing our testings. He was also assured by the divine power of the Lord, to help with his frailties and failures. Jean Dudley reminds us there is some of Peter in each of us:

> As Peter loved, I love, and in his fashion:
> With boastful promises and bursts of passion;
> Then anxious waverings and hot denials,
> And faith that drowns amid a sea of trials.
> Yet strong beyond my fitful love I see
> His love forever reaching out to me.

"There is no neutral ground in the universe," warns C.S. Lewis, "every square inch, every split second, is claimed by God and counterclaimed by Satan." We are engaged in spiritual warfare. How reassuring that we have One who Himself having been human, understands our needs, and as God, has power to make us adequate.

Jesus of Galilee, Lord of the universe, thank You for the assurance of Your understanding and power for my life.

Portrait Eighty-Two
OVERSEER

*For you were like sheep going astray, but now you have re-
turned to the Shepherd and Overseer of your souls (1 Peter2:25).*

We are often in Scripture likened in our spiritual condition to
sheep. Both Isaiah and Peter tell us that we, like sheep, have
gone astray (Isa. 53:6; 1 Peter 2:25). Christ portrayed Himself as
the Good Shepherd and us as the lost sheep. These passages
remind us that we were lost, unprotected, exposed to perils.
But Peter assured us we are now under the care of "the
Shepherd and Overseer" of our souls (1 Peter 2:25).

We would easily continue to stray and become lost without
the care and guardianship of Christ. Peter, in this text, also
reminds us that Christ became our Overseer by His sufferings,
stating, "By His wounds you have been healed" (v. 24). Our
Lord is the Good Shepherd who gave His life for His sheep. He
knows our temptations and trials and our needs, for He took
our infirmities on Himself.

Father Damien went to the unshepherded lepers on the
island of Molokai in the South Pacific. He was the only healthy
man on an island populated with lepers. One morning he was
pouring some boiling water into a pan when some of it
splashed on to his bare feet. He did not feel the pain. He
looked at them for a moment in astonishment. And then the
truth broke on him. One of the signs of leprosy is immunity to
pain. He knew in that moment that he was a leper himself. The
next time he stood in his pulpit, he commenced with the
words, "Fellow lepers." In ministering to their needs, he had
taken on himself their infirmity and suffering.

Our Lord is the Good Shepherd who gave His life for His sheep. It is by His stripes we are healed and by His death that we are born to life everlasting.

Guardian of my way, keep my feet on the pathway of the cross and lead me safely to dwell in Your house forevermore.

Portrait Eighty-Three
ADVOCATE

If anyone sins, we have an Advocate with the Father, Jesus Christ the righteous (1 John 2:1, NKJV).

The word *sin* here is in the aorist tense in the Greek and refers to a sin in the past in contrast to the present tense which would represent habitual sinning. If we are sorry for a sin we have done and are willing to renounce it, we have an Advocate who will help us receive forgiveness.

The word "advocate" here is the Greek word *parakletos* which John also uses in John 14–16 as a term for the Holy Spirit. However, there Jesus applies this word to Himself as well by saying, "He will send you Another to be your Advocate [Paraclete]" (John 14:15-16, NEB). The word means "one called alongside to help, one to plead our cause," which is the rendering of the *New English Bible* for this text.

The Holy Spirit as *Paraclete* can do many things for us. He convicts, regenerates or brings about the new birth, empowers, guides, purifies, helps us in our praying. But there is one thing the Holy Spirit cannot do for us. He cannot acquit us from our guilt of sin. Jesus Christ alone can be our Advocate, our *Paraclete*, in achieving our pardon in the divine court of justice.

In the time when this Scripture was written, the word translated *advocate* referred to one who took one's side in a trial. There is a divine law that has been broken. God's Law declares, "The soul that sinneth, it shall die" (Ezek. 18:20, KJV). We have all sinned and come under the condemnation of that

law. We are guilty. We are under the death sentence. Who can help us?

We have an Advocate—One who pleads our cause. He intercedes on our behalf. Not to prove our innocence, for we are guilty. We have grieved Him by a thousand falls, but we have an Advocate who stands on our behalf at the bar of divine justice.

Jesus—His human name as part of this text, reminds us of His understanding of our frailties and failures.

Christ—He is God's anointed. He has a unique standing with God the Father and will have the attention of the Divine Judge.

The Righteous—He has the moral qualifications fitting Him to be the Mediator between man and God.

In Rockefeller Center of New York City, there can be seen from the channel promenade overlooking the Lower Plaza, a bronze statue leafed in gold of Prometheus stealing the sacred fire for mankind. The story of Prometheus is one of the great Greek legends of the gods. In the days before men possessed fire, Prometheus took fire from heaven and gave it as a gift to men. Zeus, the king of the gods, was very angry that men should receive this gift. So he took Prometheus and chained him to a rock in the middle of the Adriatic Sea, where he was tortured with the heat and thirst of the day and the cold of the night. Zeus even prepared a vulture to tear out Prometheus' liver, which always grew again, only to be torn out again. This legend represents the pagan concept of gods, a horde of jealous and vengeful deities. How different from this title and its comforting message that Christ is our Advocate, the One who pleads our cause and defends us.

My Advocate with the Father, thank You for pleading my cause. By the merit of Your sacrifice, may I have pardon, and by the cleansing of Your Spirit, may I have purity.

Portrait Eighty-Four
ATONING SACRIFICE

He is the Atoning Sacrifice for our sins, and not only for ours but also for the sins of the whole world (1 John 2:2).

Christ is "the Atoning Sacrifice for our sins" (1 John 2:2) declares the one who knew Him better than any other human being. The word *atoning* is variously translated: "propitiation" (KJV), "expiation" (RSV), "atonement" (PH), "remedy" (NEB), "sacrifice" (JB). Each word eloquently testifies to the supreme sacrifice Jesus made on the cross for each of us.

His was a voluntary offering for us. It was the world's supreme act of self-giving and had the greatest impact of any event of history. His death set a gallows against every city skyline and redeemed a world from sin.

Atonement, simply defined as "making at-one-ment" or uniting that which was separated, is the purpose of Christ having come to earth. His birth, life, death, resurrection, and coming again are all summed up in this theological term. This mission of Christ is imaginatively expressed by Major Albert Hambleton:

> He didn't come to Jupiter,
> He didn't come to Mars,
> He didn't come to sun or moon
> Or any of the stars.
> Of all the vast created host
> From His own hand unfurled

By Jesus Christ, His only Son,
God came into our world.

He came because He wanted most
To take away sin's blight:
To frustrate every devilish scheme
And put our wrong world right.
His own volition brought Him from
His throne with splendor pearled.
But only if invited will
He come into my world.

*Divine Lord who has lavished such love on us, I give my little
all in return.*

Portrait Eighty-Five
THE AMEN

These are the words of the Amen (Rev. 3:14).

"Amen" is one of the great Bible words. It means "so be it." It also affirms that what it relates to is trustworthy and sure.

We read "Then all the people shall say, 'Amen' " no less than 12 consecutive times in Deuteronomy 27:15-26. They were saying, "So be it" in response to the reciting of the Levites of curses on sins. The Psalms introduced the word as a conclusion to praise, such as "Praise be to the Lord forever! Amen and Amen" (89:52).

In the New Testament, it is found accompanying expressions of praise and prayer, such as in Paul's doxology in Romans 11:33-36, which ends, "To Him be the glory forever! Amen." It also appears at the end of several of Paul's epistles.

But the word has its greatest association and meaning with our Lord. It is one of His most frequently used words, occurring 51 times in the Synoptics and 50 times in the Gospel of John. It is translated "verily" and is always doubled in John, used in the phrase, "Verily, verily I say unto you." Wherever Jesus uses this expression, it signifies He is giving special emphasis to a vital truth. We need to heed most carefully the "verilies" of Christ. The *New International Version,* in its updating the language without losing the meaning, translates this word when used by Christ as "I tell you the truth." For example, Jesus said to Nicodemus, "I tell you the truth, unless a man is born of water and the Spirit, he cannot enter the

kingdom of God" (John 3:5). Our Lord used this word to intensify the truth that the new birth is the invariable requisite for all mankind.

With such a close association of this word, and investing it with the authority of His person and teaching, it is not surprising that in the final book it becomes a title for Christ Himself. Christ ascribes the title to Himself in the last of the seven letters to the churches and just before the magnificent vision of the throne and end times that is given to John. Thus, it is Christ's own seal of the trustworthiness and the surety of the stupendous revelation of this book, as He declares, "These are the words of the Amen" (Rev. 3:14).

It is significant that this word "Amen" is universally the same so that Christians of all nations and languages, when they come together, unitedly praise God as all the people say, "Amen."

> *You who are the Amen, we praise You for the trustworthiness and surety of Your revelations. Help us to live by them.*

Portrait Eighty-Six
FAITHFUL AND TRUE WITNESS

*These are the words of the . . . faithful and true Witness
(Rev. 3:14).*

"I have found myself dislodged from one position after another . . . remorselessly driven. Where? To this symbol of our Christian faith which is also a gallows," confessed Malcolm Muggeridge in writing of his own pilgrimage to faith. For him it was the fraudulence and barrenness of alternatives which drove him to Christ. Muggeridge became a counterpart of Peter who also confessed, "To whom shall we go?" In Christ alone do we find the faithful and true Witness to life.

Christ uses this title of Himself in His message to the church in Laodicea (Rev. 3:14). And the title is given to our Lord as He returns in mighty triumph in the end time amid the great hallelujah chorus of heaven as described in one of the most dramatic and exalted scenes of the Bible (Rev. 19). His second coming will confirm Him as *the faithful and true Witness.*

Before the bar of our reason and life choices, we want a witness who is trustworthy. Christ is unerring in His testimony, undaunted amid life's testing and trials, and unchanging amid life's passing values. Not one single fact has ever been discovered that invalidates one word of Christ. The true discoveries of science only corroborate Christ. Truth validates Christ and Christ validates truth.

Faithful and true Witness, thank You for revealing to me the truth about God, myself, and my world.

199

LION OF THE TRIBE OF JUDAH

Do not weep! See, the Lion of the tribe of Judah . . .
has triumphed (Rev. 5:5).

The inspired seer has a strange juxtaposition of metaphors for Christ. In our text He is called the Lion and in the very next verse He is called the Lamb. Have we encountered an incompatibility in our study of the titles of Christ? Can Christ the Lamb and Christ the Lion be reconciled?

We see that both portraits are essential to Christ and His ministry. The figure of the Lamb represents His suffering and sacrifice for us. We also need the figure of the Lion that represents His conquest in His suffering and offering. The sacrifice without the conquest would have been just another in the long succession of martyrdoms in the history of man.

The *Amplified New Testament* vividly renders this verse, "Stop weeping! See, the Lion of the tribe of Judah . . . has won—has overcome and conquered!" Today there is much lamentation over the problems and perplexities of man. Our text says to us, "Stop lamenting—look to Christ who is the Mighty Conqueror!" Our world is not so much helped by those who say, "Look what the world has come to," as it is by those who declare, "Look who has come to the world!"

We need this portrait of Christ the Conqueror. Let us do away with the pictures and concepts of an anemic Christ. We need to see Christ the Lion—Christ the Invincible Conqueror for our times. Let us behold His blazing wrath over injustice, war, violence, evil. Let us see Him as the One who will come

in the role of the Mighty Conqueror.

Let us find in Him our concepts that will, when linked with our actions, bring remedial measures to the ills of life. Let us find in Him our strength to attack the injustices that assail the dignity and worth of man.

Revelation 6 deals with catastrophes of life that emanate from the opening of the seals. They represent a catalog of some of the worst disasters than can assault life: war, mourning and distress, the pale horse of death, persecution, calamities of a convulsive nature. Yet, in view of all these distresses and disasters, Christ is portrayed as the Conqueror.

While camping in Algonquin Park, Canada one summer, one of our girls, quite young at the time, was sure she could climb a mountain trail with us. Her eagerness was too sweet to resist and so we allowed her to come with the two older children as we started our climb up Lookout Trail. She danced ahead, confident of her strength. Soon the road became a trail, and the trail became frowning rocks. Finally, she sat down, exhausted. Then her father reached out his arm, and, taking hold of it, she reached the summit that would not have been possible in her own strength alone.

Life is an uphill path. It has its precipices and rocks and steep ascents. But Christ conquered for us and He will take our hands and guide us safely to the end of life's journey.

In N.B. Herrell's stirring song, "The Unveiled Christ," there is the resonant proclamation of the truth of this title:

> Once our blessed Christ of beauty
> Was veiled off from human view;
> But through suffering, death, and sorrow
> He has rent the veil in two.
> O behold the Man of Sorrows!
> O behold Him in plain view!
> Lo! He is the mighty Conqueror
> Since He rent the veil in two.*

Mighty Conqueror, enable me to live victoriously.

*Copyright 1916. Renewed 1943 by Nazarene Publishing House. Used by permission.

Our Lord's

SELF-
PORTRAITS
("I AM'S")

Portrait Eighty-Eight
THE BREAD OF LIFE

I am the Bread of Life (John 6:35).

The multitude had witnessed the miracle of the feeding of the 5,000 with the five loaves and two fishes. To escape the press of the crowd, Jesus retired to a mountain and then crossed the lake to the other side. The people followed Him by ship. Their enquiries revealed that they were still looking for His miraculous loaves. However, Jesus pointed to the Giver and said, "I am the Bread of Life."

In essence, Jesus said that what bread was to the physical life, He was to the soul. How fitting that Jesus was born in Bethlehem which was known as the House of Bread. Bread has been called the staff of life. It is the basic staple for existence. Other foods are expendable, but not bread. Christ is inexpendable to life and sustenance.

Christ discerned that the seeking of the crowd was for the material rather than for the spiritual. He said, "You are not really for Me but for the loaves I gave you which you ate and were filled." Do we not find in these words an indictment on contemporary religion? Even in what sometimes appears to be our religious duties to Christ we find ulterior motives. Have we not too often observed those who come to church for the bread that perishes? In their coming they are seeking respectability, in their service they are seeking an image of devoutness, in their giving they are seeking personal prestige or trying to compensate for a higher gift required by God. Selfish-

ness can govern even our religious pursuits.

Have we not at times sought the impersonal in religion instead of the personal, the transient instead of the eternal, the shadowy instead of the substantial? Sometimes we try to cultivate the image instead of the reality, forgetting that if we cultivate the reality the image will take care of itself.

The transient pleasures, the phantom charms, the evanescent fame and success are like bubbles. They sparkle, and like children, we reach out to them only to find that when we grasp them their charm vanishes. The intoxicating cups of the world's pleasures will turn to bitterness.

Jesus in this chapter was referring to the deepest hunger and thirst of life. There is in man a bias toward his Creator. The psalmist employed a metaphor that would as graphically as possible convey this thought when he exclaimed, "As the deer pants for streams of water, so my soul pants for You, O God. My soul thirsts for God, for the living God" (Ps. 42:1-2).

On one of those intoxicating Indian Summer days in the Pocono Mountains of Pennsylvania there was suddenly the bounding noise of a deer coming over a knoll and the eerie sound of dogs on the chase. The deer passed close enough so that I could see the desperate look in its eyes, the parched tongue hanging out of the side of its mouth. Down the mountain it ran, outdistancing its pursuers, until it reached the deep ravine and the cold fresh stream cascading over the rocks. How it panted after the water brooks! So in man there is an intense longing, thirsting hunger for God. There is a thirst that no earthly spring can slake. There is a hunger that no earthly bread can satisfy. Only Christ, who is the Bread of Life, can satisfy the deepest hunger and yearning of the soul.

Bread is needed regularly for its nourishing value. Christ, in this discourse, tells His followers that they should eat of His bread. We need to take Christ into our inmost being. We need to assimilate the truths and the reality of His presence into our daily lives. He will sustain us. He will replenish our spent strength and our exhausted store of endurance. He will give vitality and vigor to the spiritual life.

Christ sacrificed Himself to become for us the Bread of Life.

Bread of Life, satisfy the deepest hungers of my life.

Portrait Eighty-Nine
THE LIGHT OF
THE WORLD

I am the Light of the World (John 8:12).

What light is to the earth, Jesus is to mankind. Light is indispensable to life. It is a great mystery, yet it is one of man's greatest friends. In many ways physical light is analogous to the One who is the Light of the World.

The world needs light. It cannot exist or survive without it. Darkness and barrenness would prevail without light. Nothing could grow; nothing could live.

The world without Christ is a world of darkness, groping and lost. Without Christ the world is in philosophical darkness. He alone is the fulfillment of the philosopher's quest. Without Christ the world is in sociological darkness. He alone teaches the higher laws of love that contribute to true brotherhood and peace. Without Christ the world is in spiritual darkness. He alone can save man from the dark night of sin.

Light makes darkness flee. Christ, as the Light of the World, dispels the spiritual darkness. He lifts us from the shadows.

Light is the great revealer. The most beautiful flowers, the most majestic mountains are obscured in inky blackness until they are rescued from the night and bathed in the sunlight. Only then do they thrill us with the wonder of their beauty.

At the Academia in Florence, Italy we were overwhelmed with the beauty of Michelangelo's great works of sculpture, including his magnificent David. Also of interest were the unfinished statuary which revealed by their chisel marks

something of the method of Michelangelo's sculpturing. It recalled to mind his concept that he did not create these works but rather unveiled what was already in the marble, cutting away the superfluities. Thus would he give to the world his Pieta or an angel that he saw in a rough piece of marble. Christ releases from its imprisoned splendor the divine qualities within a life and reveals by His light the otherwise hidden glory and beauty of the divine imprint.

Light guides. In the dark men easily stumble and fall. Light makes possible an intelligent sense of direction and destiny.

Light permeates. It travels at its phantom speed of 186,000 miles a second. It is unhindered by space and time. Christ transcends the barriers of time and space. He is nearer than our dearest one on earth.

Light is pure. Water may start out as a pure spring but too soon it becomes impure when it comes close to man's habitations. Snow makes contact with earth's impurities when it falls from the sky. The wind and air become contaminated with man's toxic chemicals. But light may shine through the most foul medium and yet remain impeccably pure. Christ mingled amidst earth's moral pollution and yet remained spotlessly pure. He is the pure Light.

We must not forget the other side of the coin of this saying. Jesus said, "I am the Light of the World." But He also said to His disciples, "You are the light of the world" (Matt. 5:14). How do we reconcile these two sayings?

Every student of astronomy knows that there are two orders of luminaries. There is that which is its own source of light. The sun is of this order. Then there is the luminary which has no light of its own. It catches and reflects light from another source. The moon is an example of that kind of luminary. Without the light of the sun it would be a sterile, dark ball in a midnight sky. But catching the radiance of the sun, it becomes a glowing, luminous heavenly body up in our sky. Our light is a borrowed ray from the Sun of Righteousness. How wonderful it is that our lives can catch His radiance and reflect it in a darkened world.

Source of lustrous light, help me to catch and reflect Your radiance and glory.

Portrait Ninety
THE DOOR

I am the Door (John 10:9, KJV).

This title refers to the unique custom of the Eastern sheepfold. At night the shepherd would gather the sheep in a stone or other type of natural or improvised enclosure with a narrow opening. Then he would lie across that opening and literally become the door of the fold.

A traveler once, when skies were rose and gold
With Syrian sunset, paused beside the fold,
Where an Arabian shepherd housed his flock;
Only a circling wall of rough, gray rock—
No door, no gate, but just an opening wide
Enough for snowy, huddling sheep to come inside.
"So," questioned he, "then no wild beasts you dread?"
"Ah, yes, the wolf is near," the shepherd said.
"But"—strange and sweet the words Divine of yore
Fell on his startled ear: "*I am the door!*"

When skies are sown with stars, and I may trace
The velvet shadows in this narrow space,
I lay me down. No silly sheep may go
Without the fold but I, the shepherd, know.
Nor need my cherished flock, close-sheltered, warm,
Fear ravening wolf, save o'er my prostrate form."
O word of Christ—illumined evermore

For us His timid sheep—"I am the Door."

AUTHOR UNKNOWN

Christ is the Door of salvation: "By Me if any man enter in, he shall be saved" (John 10:9, KJV). Many have tried to climb the wall of redemption by vain philosophy, human effort, religious systems—but apart from Christ there is no salvation.

Lew Wallace, author of *Ben Hur*, was challenged by the noted agnostic, Robert G. Ingersoll, to give the world a book that would prove the falsity of Jesus Christ. Wallace spent many years traveling abroad researching ancient manuscripts. But, as he started to write, he realized that all his research had only proved that Jesus Christ was real in history. He became more convinced that Christ not only lived but He was divine, resurrected, and was the Saviour of men. At 50 years of age he prayed for the first time and accepted Christ as his Saviour. He rewrote his manuscript and gave the world *Ben Hur* to prove that Christ is the Son of God and the Saviour of the world. Christ is the Door of salvation.

Christ is the Door of spiritual freedom. Of the sheep who pass through this door Christ said, they "shall go in and out." This suggests activity. There is a coming and going for God. Life has deeper dimensions and broader horizons when we have a Christian perspective. His fold is not a place of confinement. The Christian life is not one of proscription and restriction. It is a life of glorious liberty. The Christian enjoys the abundant life (see v. 10).

Christ is the Door to a vital and virile life: "He shall find pasture." Life is enriched and enhanced by our communion with Him and our fellowship in the Christian community.

It is implied in this title that Christ is the Door to the fold of God. The true church, or fold, is His mystical body—that company of true followers irrespective of denominational stripe. Through Christ, the Door, we enter and become part of the great flock of God. Christ is the Chief Shepherd and Bishop of our souls.

Christ the Door, Your titles and my needs fit each other. I thank You for the abundant entrance You have given into the fold of God.

Portrait Ninety-One
THE GOOD SHEPHERD

I am the Good Shepherd (John 10:11).

In touring the famed St. Calixtus Catacombs in Rome, our attention was captivated by the third-century paintings on the rock walls. They bore a revealing testimony to the life and thought of the early Christian church. We were interested to discover among those rare paintings one of Christ as the Good Shepherd, carrying a sheep over His shoulder. This concept of Christ as the Good Shepherd has perhaps been the most endearing portrait of the Master through the centuries.

The portrait of the Good Shepherd is delineated in the beloved 23rd Psalm and other shepherd passages. The shepherd had an intimate knowledge of his sheep: "He calls his own sheep by name" (John 10:3). "I know My sheep, and My sheep know Me" (v. 14). The shepherd of the Orient had a much more intimate relation with his sheep than the shepherd of the West. In our part of the world sheep are raised mostly for meat. In the East they would be raised for their wool and milk. The shepherd would stay with the sheep sometimes as long as 10 years. Thus, the shepherd and sheep would develop a close and tender relationship.

"He goes on ahead of them" (v. 4) portrays the feet of the Good Shepherd. The shepherd did not drive his sheep; he led them. Christ has gone the way before us. He has journeyed through life's thorn-grown wilderness. He knows life's dangers and perils. The Good Shepherd leads His sheep "beside

the still waters." Otherwise a rushing current might sweep away the flock to destruction, or mask the sound of an approaching enemy. But He does not always lead us in pastures green or by waters still. Sometimes He leads us amid the tempests and down into the deep ravines of life. But there is reassurance in the presence of the Good Shepherd.

"Thy rod and Thy staff they comfort me" (Ps. 23:4, KJV). These words tell us something about the hands of the shepherd. The rod was a stout piece of wood with which the shepherd fought off the wild beasts or the marauder of the flock. Our Good Shepherd protects us from the deadly enemies of our soul. The staff was a long, crooked stick which the shepherd would gently lay on the back of the sheep to keep it from straying. There was not only the strength and protection of the shepherd's hands but also their tenderness. "Thou anointest my head with oil" (v. 5, KJV). The strong, tender hands of the shepherd would rub oil into the fleece of the sheep. Our Good Shepherd refreshes us with the balm of His tender presence.

There is also portrayed the heart of the Good Shepherd. "When He saw the crowds, He had compassion on them, because they were harassed and helpless like sheep without a shepherd" (Matt. 9:36). We are like sheep, often foolish and prone to wander. His was an urgent, active love on our behalf.

In Luke 15:4-6, Jesus likens Himself to the shepherd who had 100 sheep. Ninety-nine were safe in the fold and 1 was lost. The shepherd went into the wilderness and sought and found the lost sheep. He brought it back on his shoulders and called his neighbors to celebrate with him, "Rejoice with me, I have found my lost sheep."

The true shepherd would place himself between his flock and the peril. Jesus said, "The Good Shepherd lays down His life for the sheep" (John 10:11). His love for us was so great that He laid down His life to save us.

Our Shepherd will be there beside us when we pass through the "valley of the shadow of death." Then, with the Good Shepherd, we will dwell in our Father's house forevermore.

Good Shepherd, lead me through my life's valleys and maze to my Father's house.

Portrait Ninety-Two
THE RESURRECTION AND THE LIFE

I am the Resurrection, and the Life. He who believes in Me will live, even though he dies (John 11:25).

These words were spoken in the midst of a drama of human death and gloom. They were spoken in a situation of heartbreak and agony. This type of agony is well known to the human race, as the tender ties of human affection and association are severed, and there is, in the words of Tennyson, a longing for

> . . . the touch of a vanish'd hand,
> And the sound of a voice that is still!

That little home of Bethany that had so often been a retreat and a haven of rest for the Master had now become a morgue of gloom and dismay. Lazarus had died. There was the deep grief of the sisters and friends, and the plaintive wailing of the mourners.

In this darkest of settings Jesus gives us one of His most radiant titles. Many consider this the climax of His "I Am" statements. It is a supreme and superlative expression of His authority over life and death.

At least four times while on earth, Jesus demonstrated His authority over death. First, there was Jairus' daughter, the maid or young child that had been snatched by death at so tender an age (Matt. 9:23-26). There was the only son of the widow of Nain that was being carried out on the bier to whom

213

Jesus spoke those precious words of life, "Young man, I say to you, Get up!" (Luke 7:12-16) And there were the dramatic words of our text spoken to the one who had been dead four days and would by then be with the fetid smell of human death. In one of the most climactic moments of Bible narrative, Jesus called, "Lazarus, come out" (John 11:43), and the dead man came forth from the tomb still bound in his graveclothes. Finally there was His own mighty resurrection which gave ultimate confirmation and authority to His majestic words, "I am the Resurrection and the Life" (John 11:25).

There was the day when Jesus was in the tomb. Hearts were heavy. The crestfallen disciples on the Emmaus road represented the dismay of all followers at what seemed to be the defeat of Christ and His wonderful claims. Death had claimed Him as a victim and snuffed out the hope that had sprung from His radiant promises.

In the history of man, there was another momentous day that seemed ominous with defeat. When the decisive battle of Waterloo was fought, the people of London anxiously awaited news of the outcome of battle. In those days messages were sent by means of semaphore signals. From the top of Winchester Cathedral the people saw and read the message, "Wellington defeated" and then a blanket of fog veiled the signalers. The people of London were in deep despair at the thought of their great general being defeated. All seemed lost. But later that day the fog lifted and again the message was being signaled. Again they read, "Wellington defeated"—but this time there was more to the message. It read, "Wellington defeated the enemy." Gloom changed to glory, despair to delight, tragedy had become triumph.

So too when the fog had lifted following Calvary, the glorious message passed like wildfire, "He is risen!" and defeat was changed into victory. Christ became the great Victor over death instead of its victim. Christ the Mighty Conqueror came and cut the Gordian knot of death by the decisive thrust of His resurrection.

You who are the Resurrection and the Life, keep me ever under the spell of immortality.

Portrait Ninety-Three
THE WAY

I am the Way (John 14:6).

Jesus had just said some astonishing things to His disciples. Here, in His farewell discourse in the Upper Room, He had spoken of His Father's house and mansions and going away where the disciples would not be able to follow. These mystical statements were too much for Thomas with his practical bent of mind. He was constrained to ask, "How can we know the way?"

We are not surprised that it was the voice of Thomas in that Upper Room, questioning the Lord's statement. Thomas was well known as the Palestinian Missourian among the disciples. He always looked before he leaped. He checked his involvements carefully. It was he who later, following the Resurrection, was to say, "Unless I see the nailmarks in His hands and put my finger where the nails were and put my hand into His side, I will not believe."

Thomas had a skeptic's mind. Or could it have been a scientist's? Alas, it seems Thomas has been the victim of a bad press. A deeper study of Thomas finds him to be the realist, having an inquiring mind, and one of the most courageous and devoted disciples. Our questions are often our questings. Creative doubt can be a step forward in our faith, not the end of it. A faith hammered out on the anvil of our doubts and coming to terms with reality will be an enduring faith.

Tennyson's words could well have been written for Thomas:

"There is more faith in honest doubt, believe me, than half the world's creeds." It is difficult to retain the courage of one's doubts in this world of dangerously passionate certainties. The last word we hear spoken by Thomas in the New Testament is one of the most unreserved affirmations recorded in all the Gospels: "My Lord and my God!"

The question of Thomas, "How can we know the way?" comes echoing down the centuries. It is the pivotal question that every life must ask. We are glad Thomas asked it for in response we have one of the most radiant textual jewels of the Bible. In reply, Jesus declared, "I am the Way and the Truth and the Life. No one comes to the Father except through Me."

There are so many ways that beckon and so many voices that clamor for our attention and allegiance. Other religions and cults call out, claiming they are the way. Communism with its godless and classless society aggressively presses its claim as being the way. Science and technology seem to many to be the panacea for the world's ills. In our society, many have succumbed to the spurious claims of drugs, sex, hedonism, materialism, ambition. In our world of sharply conflicting claims and ideologies, how can we know the way?

Most of us who drive have had the experience of looking for some location. We have stopped to ask a person for directions. His complicated instructions have sometimes overtaxed our memory as well as our imagination. But there have been times when we have asked and a person has said, "Follow me. I am going that way and I will take you there." What a difference when we have had someone who has known the way and has guided us there. The psalmist said, "You have made known to me the path of life" (Ps. 16:11). Jesus does not hand us an impossible creed as the road map for life, but rather above the clamor of our world and all other voices, we hear from our text the authoritative voice of Christ, declaring: "I am the Way!" He did not say He is *a* way among many other ways. He stated, "I am THE Way." He is the only way. All other ways are dead ends.

Christ, the Way, lead me through my journey of life.

Portrait Ninety-Four
THE TRUTH

I am . . . the Truth (John 14:6).

"I am the Truth" is the second of this great trilogy of titles
Jesus gives in response to the question of Thomas in the Upper
Room. There has never been a greater need to realize the
meaning of this title than in our day of deceit and duplicity,
not only on a personal level but on an international scale.
Deception has become for many a way of life; for nations often
a policy. Pilate's question, "What is truth?" is more difficult to
answer in our time than ever before in history. What sage or
Solomon of today can discern the truth between the conflicting
claims that make the headlines of everyday's news?

Christian psychologist James R. Dolby gives a painful diag-
nosis in his book, *I, Too, Am Man* (Word): "You and I are
basically dishonest. Most of our lives have been spent learning
to play the game of deception. . . . We are caught in a pattern
of dishonesty . . . to be honest with ourselves is not
natural. . . . Because we have played the roles given us by our
subculture, and because we are afraid to tell truths about
ourselves for fear of personal rejection and loss of love, we find
the task of self-discovery very difficult—and sometimes
impossible."

Winston Churchill put it whimsically: "Every now and then
someone will bump into the truth. Usually he picks himself up
and goes on."

Keith Miller in his book, *The Taste of New Wine* (Word), gives

217

a similar indictment: "In the church there was an amazing lack of basic honesty. It wasn't so much that people lied. We just had an unspoken agreement not to press the truth—when it seemed that the truth might hurt the leaders or someone else's feelings—or really rock the boat. . . . Consequently, we lived in a world of subtle duplicity of which we Christians were the contributing cause."

Dr. M. Scott Peck, integrating the insights of psychology and religion, in his book *People of the Lie* (Touchstone), makes the statement, "Wherever there is evil, there's a lie around. Evil always has something to do with lies." This bestselling author has no illusion about the source of lies: "I know no more accurate epithet for Satan than the Father of Lies." How easy to lie, even for religious people. Lying takes many subtle forms—exaggerations to make impressions, shading the truth on an income tax return or compensation form, lack of complete truth in appealing for funds, to twist a meaning to gain a point, offering a false excuse to cover a failure or protect our image. Christ who is the Truth, calls each of us to be "valiant for the truth."

Truth "sways the future" as James Russell Lowell reminds us in *The Present Crisis:*

> Once to every man and nation
> Comes the moment to decide,
> In the strife of truth and falsehood,
> For the good or evil side . . .
> Truth forever on the scaffold,
> Wrong forever on the throne,
> Yet that scaffold sways the future,
> And, behind the dim unknown,
> Standeth God within the shadow,
> Keeping watch above His own.

Christ does not give us a precept but a Person; not a what, but a who; not a code or a creed, but His own character. Christ Himself was the standard that would determine truth. He was the embodiment of truth. He was Truth incarnate.

Crystal Christ, help me to be truthful, authentic.

Portrait Ninety-Five
THE LIFE

I am . . . the Life (John 14:6).

"I am the Life" is the final title of this superb trilogy given by
Christ in the Upper Room. It is an astonishing statement. Any
other person would have to say, "I am a life." But Christ
declared, "I am *the* Life." Once again the definite article, "the,"
makes our Lord's statement resonate a sublime truth.

Christ is the Source of all life. The life in our cosmos is
derived from the provision and providence of the Trinity. The
air we breathe, the water we drink, the food we eat, our very
being—all comes to us by Divine providence. We are mere
creatures of our Creator, reflections of His goodness and love.

Christ is also the Source of life with purpose. He rescues life
from becoming inane. He redeems it from being merely exis-
tence. The Life He gives has to be spelled with a capital L. He
gives qualitative dimension to life, making it supremely pur-
poseful. "I have come that they may have life, and have it to
the full" (John 10:10) is His proclamation on the life He gives.

Apart from Christ, there is no true life. Without Him it is as
described in the words of Shakespeare's *Macbeth:*

> Life's but a walking shadow
> A poor player
> That struts and frets
> His hour upon the stage
> And then is heard no more.

219

It is a tale told by an idiot,
full of sound and fury, signifying nothing.

Apart from Christ, the words of Biff, standing at his father's graveside in Arthur Miller's celebrated play, *Death of a Salesman*, become life's epitaph: "He never knew who he was." Our meaning and purpose for life are found alone in Christ. In Him we are something more than a cosmic accident, a fortuitous concourse of atoms, a restless protoplasm, a pawn of the universe, the plaything of an inscrutable fate, enchanted dust, an animated clod. In Christ we become sons of God.

Dag Hammarskjold, among his remarkable selections in his diary, published under the title *Markings*, records an incisive comment on the tragedy of missing out on life: "He was a member of the crew of Columbus' caravel. He kept wondering whether he would get back to his home village in time to succeed the old shoemaker before anyone else could grab his job." We smile—but what trivialities do we permit to dominate our lives? What petty ambitions or obsessions keep us from life's richest discoveries, its immortal quests.

The book, *In Search of Excellence*, by Peters and Waterman (Harper & Row), created not only a publishing sensation but also a management cult. Its popularity suggests people want to be "excellent." The 43 companies in the study undertaken were characterized by eight attributes that emerged as the distinctions of excellent companies. If business makes major investments to pursue excellence, how much more vital for us to assure excellence of life.

Christ is the Source of excellence of life. He helps us become the best that we can be. In Him we become creative, productive, responding adequately to change or crisis, our potential most fully actualized.

The Lord is also our Source of eternal life. We derive life from Him, are energized by Him to live, grow, and go on to life eternal.

Christ the Way, lead me, for without You there is no going. Christ the Truth, illumine me, for without You there is no knowing. Christ the Life, live in me, for without You there is no growing.

Portrait Ninety-Six
THE TRUE VINE

I am the true Vine (John 15:1).

It is possible that this allegory was suggested by the sight of vineyards on the way from the Upper Room to the Garden of Gethsemane. Vineyards were common in that part of the world. Christ's parables refer to them. The vine appeared on Jewish coinage, was often carved on the door of a synagogue and according to Josephus was the symbol carved upon the great door of the temple. The vine was interwoven in the life and thought of Jesus' hearers.

There is a twofold concept in this parable. Christ is the Vine. We are the branches. It indicates the most intimate and vital union. The branch draws its very life from the vine. It is intertwined with it and partakes its very nature from the vine. The soul is ingrafted into Christ. The Christian confidently sings, "My soul is now united to Christ the Living Vine."

In His high priestly prayer our Lord prayed, "That all of them may be one, Father, just as You are in Me and I am in You" (John 17:21). Is not this spiritual union with Christ one of the wonders of the Christian life? It was the magnificent obsession of Paul. This myriad-minded professor of the Christian faith no less than 164 times in his 13 epistles uses the phrase or its equivalent, "In Christ."

There takes place a union of wills. There is a fusion of our will with God's will. The conflict of life is basically a conflict of wills—man's will in conflict with God's will. Victory comes

when man's will is surrendered to God.

There is also a union of purpose. When united to Christ we are no longer divided personalities suffering the dichotomy of the carnal and the spiritual natures. We live to fulfill His holy purpose for our life.

This union is conditional. Christ said "If you abide in Me" (John 15:7, NKJV). There are many things that would interpose themselves between the vine and the branches. There are forces that would break the union and rob the branch of its life-giving power from the vine. The writer of the Song of Solomon enjoined, "Take us the foxes, the little foxes, that spoil the vines: for our vines have tender grapes" (2:15, KJV). Often the little things spoil the luster and richness of life. The little foxes of uncontrolled temper, undisciplined desires, debilitating lethargy, careless talk, often spoil the vineyard of our lives. For indeed the grapes of life are tender and are easily spoiled.

Union with Christ the Vine also involves a purging. "He trims clean" (John 15:2), says Christ of the fruitful branch. The Greek verb *kathairo* denotes the basic idea of purity. To abide in Christ involves a purifying of heart and life. We must be weaned from all lesser loves, cleansed from selfishness, and sanctified by His Spirit. Too many Christians seem content with spiritual mediocrity. The vine was more extensively pruned than any other tree, often to the very stump. But the more the dead branches were cut off and the greater the pruning or purging, the more vigorous and fruitful the growth. When life is purged of dead things then it will manifest its most virile life in Christ.

The union of the branch with the vine was also productive of fruit. The products of the vine from the Jerusalem area were prized throughout the world for their rich taste and quality. There is a spiritual fertility that results from union with Christ. A mature tree is a fruit-bearing tree. There is the fruit of the Spirit that produces Christlike character (see Gal. 5:22-23). There is also the fruit of service.

Christ, the true Vine, I would be united to You as the branch is to the vine. Purge my spirit of all dead things and make me fruitful for You.

Portrait Ninety-Seven
THE ALMIGHTY

I am . . . the Almighty (Rev. 1:8).

This self-ascribed title of our Lord is as His signature at the beginning of the Book of Revelation. This magnificent final book of the Bible is "The Revelation of Jesus Christ." Our Lord's "I am" statement of His infinity and omnipotence at the outset gives the divine imprimatur to awesome revelations that follow.

As the Almighty, Christ has no limit to His power. His attribute of omnipotence and His infinite love for us assure His sovereignty and care for us in a world that sometimes seems on a collision course with self-annihilation. We do not draw our comfort from our frail hold on Him, but rather from His mighty grasp of us.

H.E. Fosdick quotes a poem in one of his books that speaks of Christ's superiority in history:

I saw the conquerors riding by
 With cruel lips and faces wan:
Musing on kingdoms sacked and burned
 There rode the Mongol Genghis Khan;

And Alexander, like a god,
 Who sought to weld the world in one;
And Caesar with his laurel wreath;
 And like a thing from Hell the Hun;

And, leading like a star, the van,
 Heedless of upstretched arm and groan,
Inscrutable Napoleon went,
 Dreaming of Empire, and alone . . .

Then all they perished from the earth,
 As fleeting shadows from a glass,
And, conquering down the centuries,
 Came Christ the swordless on an ass.

Almighty Lord, thank You for holding my life secure in Your all-powerful hands.

Portrait Ninety-Eight
LIVING ONE

I am the Living One (Rev. 1:18).

"Death is a black camel which kneels besides every man's gate": is a saying from the Eastern world where a camel kneels to take on its rider. The invincible reaper knocks ultimately at every door. "Never send to know for whom the bell tolls," cried John Donne, "it tolls for thee." Mankind is haunted and hounded by a fear of death with a feeling of being constantly stalked by this dread enemy

But the New Testament is a book about life—spiritual life, abundant life, eternal life. It realistically confronts death, but does so in the context of the person and ministry of Christ.

The final book of the Bible is called "The Revelation of Jesus Christ." It is the only book that portrays Him as He truly is. The Gospels present Him in His humanity and earthly ministry, climaxing with His resurrection and ascension. But Revelation takes up where the Gospels leave off and portrays the glorified Christ, the Christ of celestial majesty, the triumphant Christ enthroned in heaven, who will mightily return to earth and set up His eternal kingdom. It is the book of the unveiled Christ.

In the opening chapter, John records the awesome vision given to him of Christ (vv. 13-16). John was struck down by the dazzling splendor of the vision. Then the hand that held the stars in their courses was placed on the head of John in comfort and the assuring words were spoken, "Do not be afraid. . . . I

am the Living One; I was dead, and behold I am alive forever and ever! And I hold the keys of death and Hades" (vv. 17-18).

What blessed assurance for Christians of all ages. Christ is alive. And He has the keys to the gates of death and hell.

Has the gate of death opened to admit your beloved—parent, child, loved one, friend? Jesus was there with the keys of death. He has the key to every grave in every quiet country graveyard and crowded city cemetery. He is the custodian of the treasure beneath that mound of earth, decked with fragrant flowers. His own mighty resurrection and power are the keys that unlock that gate and bid the imprisoned body arise to newness of life in likeness of His own. He is the Living One and because He lives, we shall live also.

At the age of 80, Tennyson, Poet Laureate of the Victorian Age, was taken from his summer home to his winter residence on the Isle of Wight. His health failing, he wrote from his sickbed on a scrap of paper a poem filled with imagery from that voyage and the emotions that relate to dying and the glorious hope of seeing Jesus at the end of life's voyage. The closing line of his "Crossing the Bar" is one of the great poetic statements of faith:

> Sunset and evening star,
> And one clear call for me!
> And may there be no moaning of the bar,
> When I put out to sea.
> For tho' from out our bourne of time and place
> The flood may bear me far,
> I hope to see my Pilot face to face
> When I have cross'd the bar.

Christ, the Living One, help me to live so that when the shadows lengthen and the evening of life comes, I will find a safe lodging, and the blessedness of Your presence.

Portrait Ninety-Nine
THE ROOT AND THE OFFSPRING OF DAVID

I am the Root and the Offspring of David (Rev. 22:16).

Jesus, in the epilogue of the Book of Revelation, guaranteed the truth of this awesome book. He certified that the vision John shared is authentic: "I, Jesus, have sent My angel to give you this testimony for the churches" (Rev. 22:16). The astonishing contents and character of the book warrant the guarantee of the Lord Himself.

Then, the Lord throws out His credentials as the Guarantor with this next to last of His "I am" titles; "I am the Root and the Offspring of David." We have already considered two titles that have kinship with this one: *Branch* (Isa. 11:1) and *Son of David* (Matt. 1:1). But this title, though related, goes far beyond the other two.

First, Jesus declared Himself to be the fulfillment of the age-old prophecy that the Messiah would come from the family of David. The title is no longer prophetical; here it is fulfilled in Christ. As the One who fulfilled all the prophecies, He has the authority to guarantee this stupendous revelation that completes and consummates the Word of God.

Second, Christ declared Himself not only to be the Offspring of David but also the source of origin of Israel's great king. He is both the root and the shoot, the source and the seed of David. The Lord is the eternal source of David's being as well as his promised descendant.

This title requires spiritual bifocals to perceive the portrait it

gives of Christ. It presents the "distant" view of the transcendent Christ. It helps us look far down the corridors of time to see Him as the eternal Christ, the timeless One. It is a vision of Christ greatly needed in our day. We need to see Him in this age of power as the omnipotent Christ, in this age of knowledge as the omniscient Christ, in this age of electronic marvels as the omnipresent Christ, in this age of dynamic change as the immutable Christ, in this age of star-destined rockets as the cosmic Christ.

But we of course also need the "close" view of the immanent Christ, the One who is near. We take heart that the Christ of the galaxies is the Christ of our generation, He who inhabits the paths of the stars walks the paths of my life. He who is the timeless One occupies my brief moment of history. He who is enthroned in heaven is enthroned in my heart. He who knows every star by name knows my name, my need.

He who presents His impeccable credentials to attest the truth of this book, is the One whose authority, both in the here and now and in eternity, will grant and guarantee His revelation to my life. I can be assured that the vision I have of Christ, in His mercy and majesty, is authentic because it comes from the Lord Himself. He has given us His Spirit to testify of Him (John 15:26) so we may know His grace and glory, His love and power.

Christ, thank You for the guarantee of Your Word and revelation to my life.

Portrait One Hundred
THE BRIGHT MORNING STAR

I am . . . the bright Morning Star (Rev. 22:16).

Immanuel Kant wrote: "Two things fill the mind with ever new and increasing wonder and awe—the starry heavens above me and the moral law within me." My favorite sight in nature is the spectacle of a star-bejeweled sky on a dark night. It fills the soul with reverence to contemplate not only the beauty of the stars but their fathomless distance and titanic size. If the stars could be seen only once in every hundred years, it would be the greatest celebration of the century.

Enshrined in our archives of family memories is one evening when we were camping in the north woods of Canada. After our evening campfire had died down, we walked with our children down by the lakeside where we could view the open sky. It was one of those dark clear nights, and away from any artificial lights, the star-spangled sky sparkled in breathtaking beauty and majesty. Our son, then about seven years of age, looked up, and in a tone of awe and reverence said, "I never knew there were so many stars."

In our highly urbanized life, very few people ever really see the stars. But every person of Christ's day had a picture in mind when Christ said, "I am the Bright Morning Star." The stars figured prominently in the life of the Eastern traveler.

The morning star heralds the dawn of a new day. Christ ushered in a new age. His coming split time in two. His life gave promise of a new and bright future.

On several fishing trips to northern Canada with my son, we drove through the night. It was always interesting to see the gradual approach of dawn in the sky in that area where no electric lights or buildings obscured the view of the stars. The stars of the sky would gradually give way to the light until finally there was only one star shining. All others had faded from view except for the morning star.

Christ, as the Bright Morning Star, shines brightly when all other stars of our life fade away. Those things which now shine so brightly on the horizon of our lives will someday fade and vanish away. The stars of prestige, position, possessions, and persons dear to us will one by one grow dim and fade away. But after everything else has vanished, Christ will still shine brightly. He will shine on in the darkest night and will radiantly beam over the horizon of life when the dawn breaks and the shadows flee away.

As the morning star is the brightest star in the sky, so is Christ the most radiant light ever to shine in our world. All other luminaries pale into insignificance compared to the brilliance of His life. He is the peerless One of all history.

For many centuries, man charted his journeys by the stars. Sailors navigated the seas with their eyes on the stars. The stars were the road maps, the directional signs for their times. They would make their way over the tractless wilderness by the guidance they found in the stars.

An artist once drew a picture of a lone man rowing his little boat on a dark night. The wind is fierce, the waves crest and rage around his frail bark. But there is one star that shines through the dark and angry sky above. On that star the voyager fixes his eyes and keeps rowing on through the storm. Beneath the picture are the words, "If I lose that I'm lost."

From Christ alone can we take bearings for our journey on the sea of life. Our boat is small and the sea is so wide. But the compass needle of life will cease its oscillations when its directional point is turned toward the One who is the Bright Morning Star. Like a mariner, we may reckon all our decisions and directions from that Star.

Radiant Christ, guide my life over the tractless pilgrimage it must make.

Index

PORTRAITS OF CHRIST IN ALPHABETICAL ORDER

232

Index

PORTRAITS OF CHRIST
IN ORDER OF BIBLE REFERENCE

1. Genesis 3:15 *Offspring of the Woman*
2. Genesis 49:10, NKJV *Shiloh*
3. Numbers 24:17 *Star*
4. Numbers 24:17 *Scepter*
5. Job 19:25 *Redeemer*
6. Song of Solomon 2:1 *Rose of Sharon*
7. Song of Solomon 2:1, TLB *Lily of the Valley*
8. Isaiah 9:6 *Wonderful Counselor*
9. Isaiah 9:6 *The Mighty God*
10. Isaiah 9:6 *The Everlasting Father*
11. Isaiah 9:6 *Prince of Peace*
12. Isaiah 11:1 *Branch*
13. Isaiah 11:10 *Banner for the Peoples*
14. Isaiah 53:1 *Arm of the Lord*
15. Isaiah 53:3 *Man of Sorrows*
16. Isaiah 55:4 *Leader and Commander*
17. Jeremiah 23:6 *Lord Our Righteousness*
18. Daniel 7:9 *Ancient of Days*
19. Daniel 9:25 *Anointed One (Messiah)*
20. Haggai 2:7, NKJV *Desire of All Nations*
21. Zechariah 9:9 *King*
22. Malachi 3:1 *Messenger of the Covenant*

23.	Malachi 4:2	*Sun of Righteousness*
24.	Matthew 1:1	*Son of David*
25.	Matthew 1:21	*Jesus*
26.	Matthew 1:23	*Immanuel*
27.	Matthew 2:23	*Nazarene*
28.	Matthew 9:15	*Bridegroom*
29.	Matthew 11:19	*Friend*
30.	Matthew 12:18	*Servant*
31.	Matthew 20:28	*Son of Man*
32.	Matthew 21:11	*Prophet*
33.	Mark 1:24	*Holy One*
34.	Mark 6:3	*Carpenter*
35.	Mark 6:3	*Brother*
36.	Luke 1:69	*Horn of Salvation*
37.	Luke 1:78, NKJV	*Dayspring*
38.	Luke 2:12	*Baby*
39.	Luke 2:43	*The Boy Jesus*
40.	Luke 4:23	*Physician*
41.	Luke 23:6	*Galilean*
42.	John 1:1	*Word*
43.	John 1:29	*Lamb of God*
44.	John 1:41	*Christ*
45.	John 3:2	*Teacher*
46.	John 3:16, NKJV	*Only Begotten Son*
47.	John 4:9	*Jew*
48.	John 4:10	*Living Water*
49.	John 4:42	*Saviour*
50.	John 6:35	*Bread of Life*
51.	John 8:12	*Light of the World*
52.	John 8:58	*I Am*
53.	John 10:9, KJV	*The Door*
54.	John 10:11	*The Good Shepherd*
55.	John 11:25	*The Resurrection and the Life*
56.	John 14:6	*The Way*
57.	John 14:6	*The Truth*
58.	John 14:6	*The Life*
59.	John 15:1	*The True Vine*

60.	John 20:16	*Rabboni*
61.	John 20:28	*God*
62.	Acts 10:42	*Judge*
63.	1 Corinthians 5:7	*Our Passover*
64.	1 Corinthians 10:4	*Rock*
65.	1 Corinthians 15:45	*The Last Adam*
66.	2 Corinthians 9:15	*Indescribable Gift*
67.	Ephesians 1:6, NKJV	*Beloved*
68.	Ephesians 2:20	*Chief Cornerstone*
69.	Ephesians 4:15	*Head*
70.	Ephesians 5:23	*Head of the Church*
71.	Philippians 2:11	*Lord*
72.	Colossians 1:15	*Image of the Invisible God*
73.	Colossians 1:15	*Firstborn over All Creation*
74.	Colossians 3:11, NKJV	*All in All*
75.	1 Timothy 1:1	*Our Hope*
76.	1 Timothy 2:5	*Mediator*
77.	1 Timothy 2:5	*The Man*
78.	1 Timothy 2:6	*Ransom*
79.	1 Timothy 6:15, NKJV	*Blessed and Only Potentate*
80.	1 Timothy 6:15	*The King of Kings*
81.	Hebrews 1:2	*Heir of All Things*
82.	Hebrews 1:3	*Radiance of God's Glory*
83.	Hebrews 1:3	*Exact Representation of His Being*
84.	Hebrews 2:10, RSV	*Pioneer of Salvation*
85.	Hebrews 3:1, RSV	*Apostle of Our Profession*
86.	Hebrews 6:20	*High Priest*
87.	Hebrews 7:22	*Guarantee of a Better Covenant*
88.	Hebrews 12:2, RSV	*Pioneeer of Our Faith*
89.	1 Peter 1:1	*Jesus Christ*
90.	1 Peter 2:25	*Overseer*
91.	1 John 2:1, NKJV	*Advocate*
92.	1 John 2:2	*Atoning Sacrifice*
93.	Revelation 1:8	*The Almighty*
94.	Revelation 1:18	*The Living One*
95.	Revelation 3:14	*The Amen*

96. Revelation 3:14 *Faithful and True Witness*
97. Revelation 5:5 *Lion of the Tribe of Judah*
98. Revelation 22:13 *Alpha and Omega*
99. Revelation 22:16 *The Root and the Offspring of David*

100. Revelation 22:16 *Bright Morning Star*